Windows on Central Park

THE LANDSCAPE REVEALED

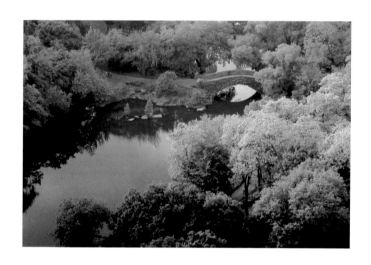

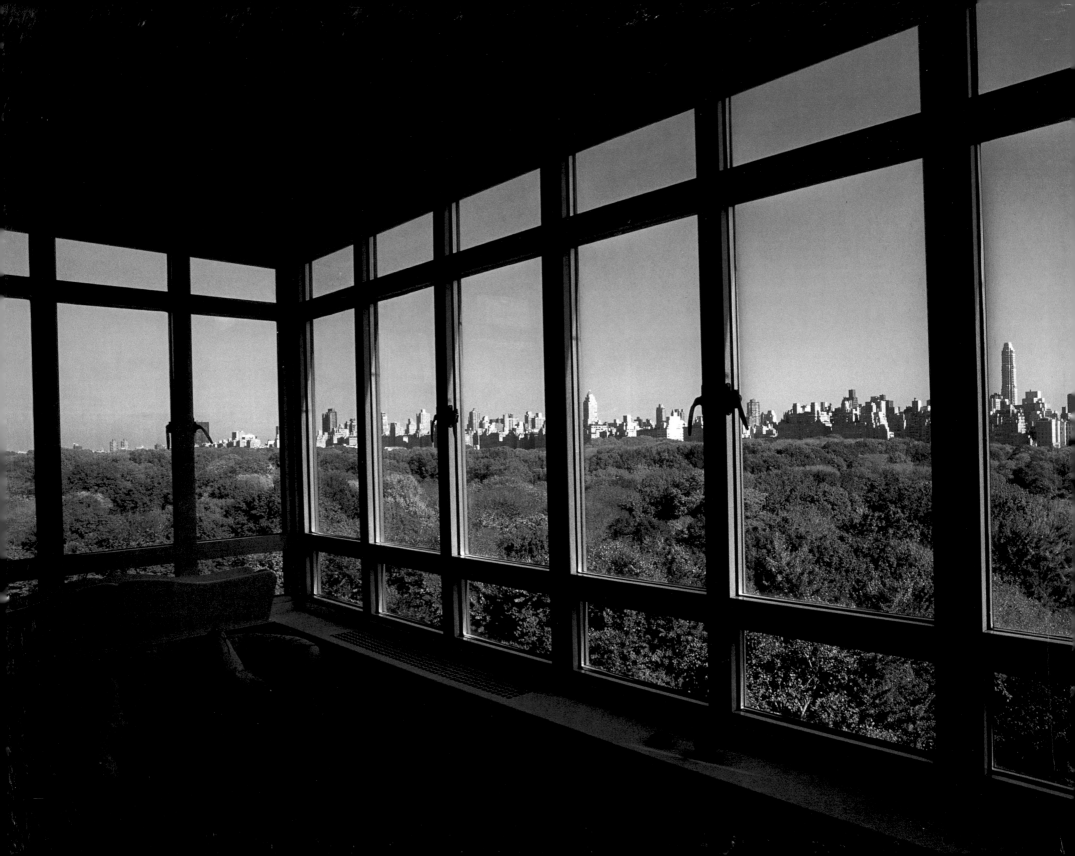

Windows on Central Park

THE LANDSCAPE REVEALED

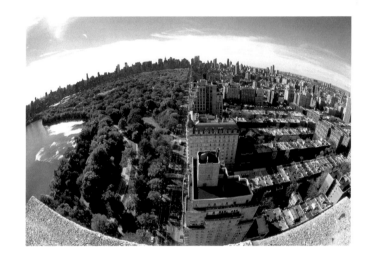

BETSY PINOVER SCHIFF

*View from a 3rd-floor window
on Central Park West at 63rd St.*

4880 Lower Valley Road Atglen, Pennsylvania 19310

Schiffer Books are available at special discounts for bulk purchases for sales promotions or premiums. Special editions, including personalized covers, and corporate imprints can be created in large quantities for special needs. For more information contact the publisher:

Published by Schiffer Publishing Ltd.
4880 Lower Valley Road
Atglen, PA 19310
Phone: (610) 593-1777; Fax: (610) 593-2002
E-mail: Info@schifferbooks.com

For the largest selection of fine reference books on this and related subjects, please visit our website at
www.schifferbooks.com
We are always looking for people to write books on new and related subjects. If you have an idea for a book please contact us at the above address.

This book may be purchased from the publisher.
Include $5.00 for shipping.
Please visit your bookstore first.
You may write for a free catalog.

In Europe, Schiffer books are distributed by
Bushwood Books
6 Marksbury Ave.
Kew Gardens
Surrey TW9 4JF England
Phone: 44 (0) 20 8392 8585; Fax: 44 (0) 20 8392 9876
E-mail: info@bushwoodbooks.co.uk
Website: www.bushwoodbooks.co.uk

ACKNOWLEDGMENTS

My special thanks to the many dozens of people who gave me the opportunity to photograph from windows and terraces in their homes and offices. Particular appreciation goes to Rosette Arons, Rene and Stanley Blau, Judy Carson, Nancy Drosd and Charles Schwartz, Irene Duell, Natalie Eigen, Elizabeth and Dale Hemmerdinger, Dorothy Hoffman, Linda James, Joseph and Bette Kessler, Patrick Lappin, Lisa Levi, Brigitte Linz, George Mills, Elizabeth Pozen, Kathy Schenker, Sheldon Solow, Angela Thompson, Alan Winters, Elizabeth Anne Wright, and Miriam Zuger. Gratitude goes to others, including Michael Gould, Heidi Stamas, and Bob and Andrea Berger, who opened many doors through introductions they made on my behalf.

I wish to thank friends who offered valuable advice: Stephen Lawrence, Mary Jane Pool, Fern Schad, and Helen Searing. I am also ever grateful for the encouragement of my husband, Edward L. Schiff.

My special appreciation to those who generously contributed quotes to the book. Credit goes to Julie Duquet for her design expertise.

My sincere thanks to Douglas Blonsky, President of the Central Park Conservancy, for his assistance, support, and for writing the Foreword to this book.

Above all, my appreciation goes to all those who work generously and tirelessly to support the Central Park Conservancy that makes possible the continued beauty of this glorious Park.

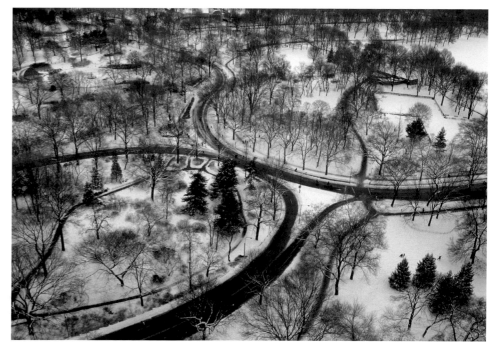

View from Central Park West at 72nd Street.

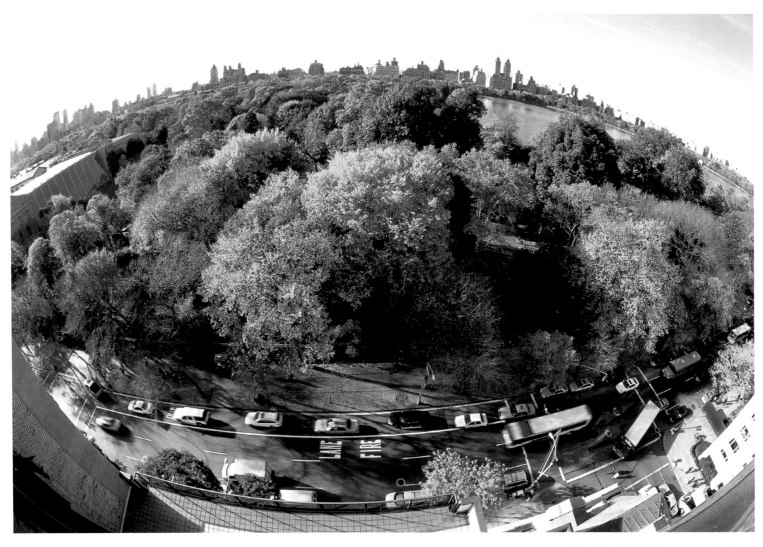

View from Fifth Avenue at 86th Street.

FOREWORD

Central Park is justifiably called a jewel in the heart of Manhattan. It spans 843 acres that include seven water bodies, 250 acres of lawns, and 136 acres of woodlands. It is home to 24,000 trees and attracts more than 275 species of migratory birds.

It is no surprise that this ecological masterpiece inspired Betsy Pinover Schiff's revelatory photographs. From the vantage points of windows, terraces, and balconies of surrounding buildings, she offers new and often astounding perspectives on the landscape of Central Park. She sees and feels both the dramatic and lyric moods evoked by grand vistas of the Park's natural beauty in its changing seasons. Her eye catches fleeting moments in which shadow and color form indelible impressions on us. Her images enable us to greater appreciate Central Park as a marvel of both urban ecology and landscape architecture.

None of these views could have been imagined by Park designers Frederick Law Olmsted and Calvert Vaux when the Park was constructed more than 150 years ago. They could never have envisioned that buildings on the Park's perimeter, which then did not exist, could become some of the most coveted real estate in New York. Although the City has mushroomed, the Park remains as its designers intended—a place of recreation and repose for New Yorkers. Today it is enjoyed by approximately thirty-five million visitors every year from all over the world.

It takes the support of many to keep the Park as beautiful as it appears in Betsy's photographs. Central Park is cared for by the Central Park Conservancy, founded in 1980. Fulfilling its mission to restore, manage, and enhance Central Park, the Conservancy has invested more than $530 million in the Park, in partnership with the public and with support from the City of New York. Conservancy crews care for the Park's lawns, trees, lakes, streams, and woodlands; install hundreds of thousands of plants annually, including bulbs, shrubs, flowers and trees; maintain 9,000 benches, 26 ball fields, and 21 playgrounds; preserve 55 sculptures and monuments, as well as 36 bridges; remove graffiti within 24 hours; collect over 5 million pounds of trash a year; and provide horticultural support to City parks.

As *Windows on Central Park* shows us, the Park is not only an unparalleled encounter with nature from within, but is also a magnificent landscape viewed from above.

Douglas Blonsky
President, Central Park Conservancy
and Central Park Administrator

PHOTOGRAPHER'S PREFACE

One night in 2003, 160 festive dinners were hosted in apartments surrounding Central Park in celebration of the Park's 150th anniversary and as a means to raise money for the Central Park Conservancy's important work. Reading about the event a couple of years later stimulated my imagination to embark upon a photographic journey exploring the Park's landscape from above.

I recalled the marvelous photographs of Ruth Orkin, published in the 1970s, taken from her window on Central Park West. If she could capture all that beauty and activity from one single window, what would I find from windows on all sides of the Park?

As a photographer of gardens and landscape architecture, my primary interest was the landscape of the Park rather than the city skyline that surrounds it or even the human activity within it. My focus was its changing colors, textures, and shadows from season to season, from early morning light to the darkness of night.

My first foray was from a friend's apartment on the eighth floor of Central Park West at 67th Street where, chilled by cold winds on his terrace, I was dazzled by the view of Tavern on the Green and the snow-laden Park below. I wondered what I would see on higher floors in the same building or a few blocks south, and wondered what this same view would offer in a different season or time of day. The scope of my self-imposed challenge grew with every apartment I visited.

Friends and strangers alike, excited by my project, contacted their friends on other floors or in neighboring buildings to request that I be permitted to photograph. In so doing, I obtained access to more than one hundred apartments. Many of these owners were three and even four times removed from the person who made the original request on my behalf. In addition to private apartments, I photographed from museums, hotels, offices, restaurants, and foreign missions on the Park, from as low as the third floor to as high as the sixty-seventh floor.

The trust and hospitality of New Yorkers I encountered was beyond all expectation. The owners of the first apartment I visited, on Central Park West and 97th Street, left their key with the doorman while they were at work, even though they had never met me. One elderly lady wasn't satisfied until I departed with her key so that I could return any time I wanted. A couple on Central Park South gave me a glass of fine Cabernet Sauvignon to sip while I photographed from their penthouse terrace. And I think fondly of the woman who placed bed sheets and blankets on her small terrace prior to my arrival so that my feet wouldn't get wet from the snow that had accumulated.

Not all was easy but I was energized by the challenges. Arranging access to apartments and scheduling appointments to meet with the owners' constantly changing lives was time-consuming and complicated. Windows were an ongoing problem as many do not open wide enough to fit a camera lens and some do not open at all. Perhaps most important, I was always at the mercy of weather and light conditions which frequently disappointed me upon arrival. And I often

found myself battling wind or snow on high terraces, sometimes preventing me from taking any photos at all.

Of the homeowners I met, perhaps sixty per cent exclaimed with great pride "*I have the most wonderful view of Central Park.*" I learned that people whose home or office windows face the Park consider their views to be among the treasures of their lives.

While I was simultaneously working on other assignments and projects, my Central Park journey continued intermittently for more than five years. It is a project that could go on forever, as there are hundreds of moments a day for every window that looks to the Park.

Among all the fleeting moments, the camera can select only one instant at a time to make reality permanent. It has been my pleasure and privilege to select those moments for this book.

Betsy Pinover Schiff

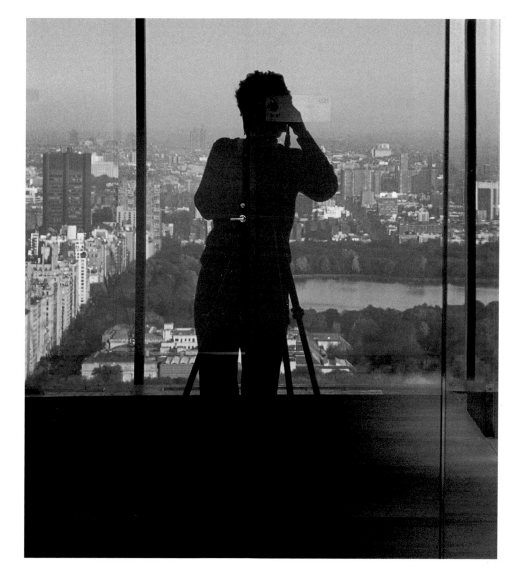

Window view and reflection of photographer, 9 West 57th Street.

SUMMER

A 3rd-floor window on Central Park West looks to full-leafed trees.

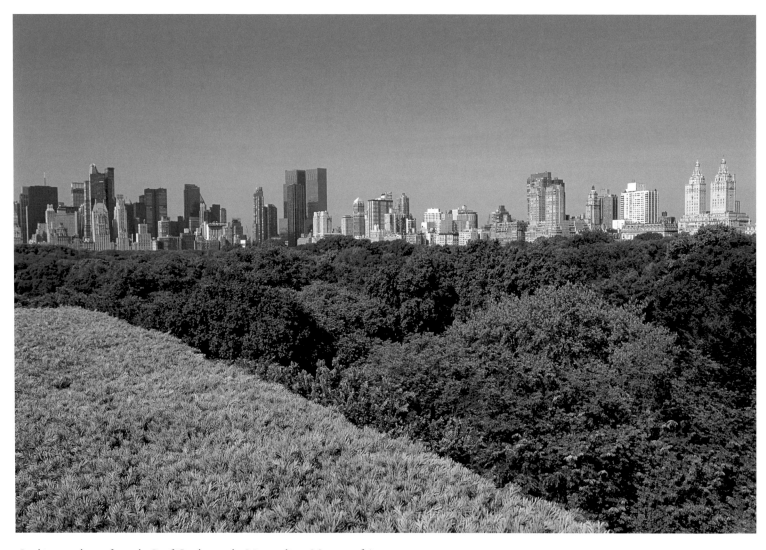

Looking southwest from the Roof Garden at the Metropolitan Museum of Art.

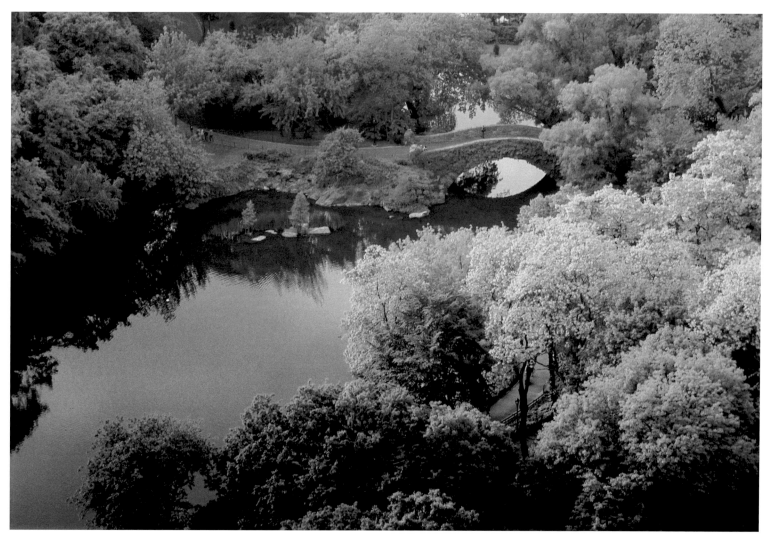

Gapstow Bridge, a stone structure from 1896 that spans the Pond, seen from the Sherry Netherland Hotel on Fifth Avenue.

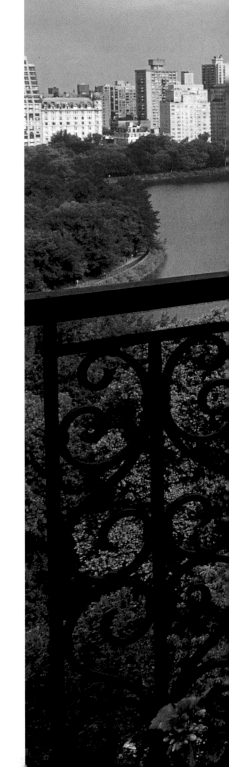

*"As a native Californian, I freely admit it. I **need** to live on the Park. I know how this sounds but I just don't care. I had an apartment on Central Park South for thirty years and when I remarried, I moved uptown. To Fifth Avenue. I think it was the views that closed the deal. We look over the Metropolitan Museum and the Reservoir. We never close the shades. We don't want to be deprived of the vista. Belvedere Castle. The bridal path. Spectacular autumn foliage and then the cherry trees in spring and the fireworks on New Year's Eve. Water views year 'round. The heart of the city. Central Park."*

CANDICE BERGEN
Actress

A Fifth Avenue terrace with colorful plants overlooking the Jacqueline Kennedy Onassis Reservoir ("the Reservoir").

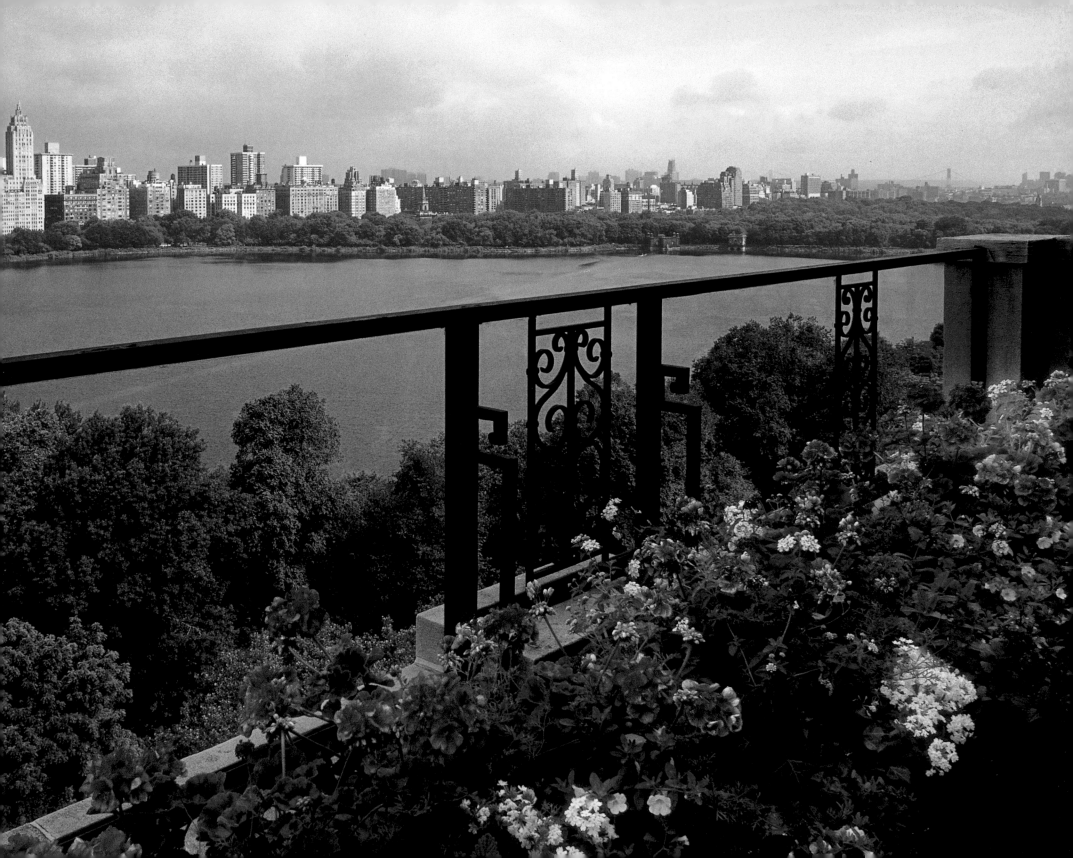

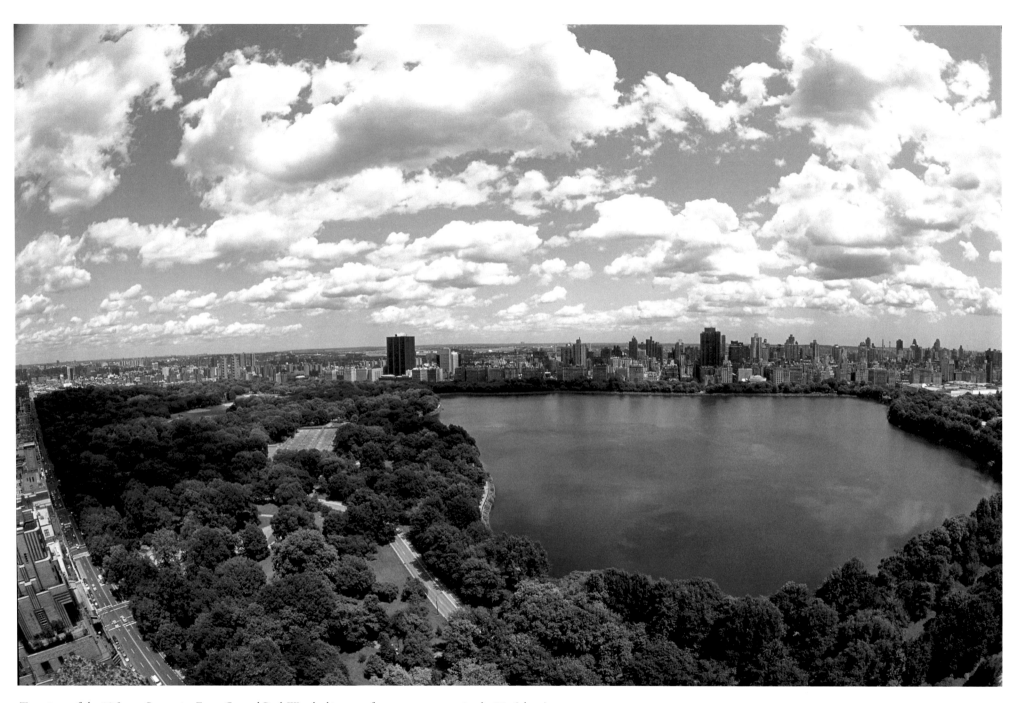

Two views of the 106-acre Reservoir: From Central Park West looking east from an apartment in the 90s (above); from a Fifth Avenue terrace (opposite).

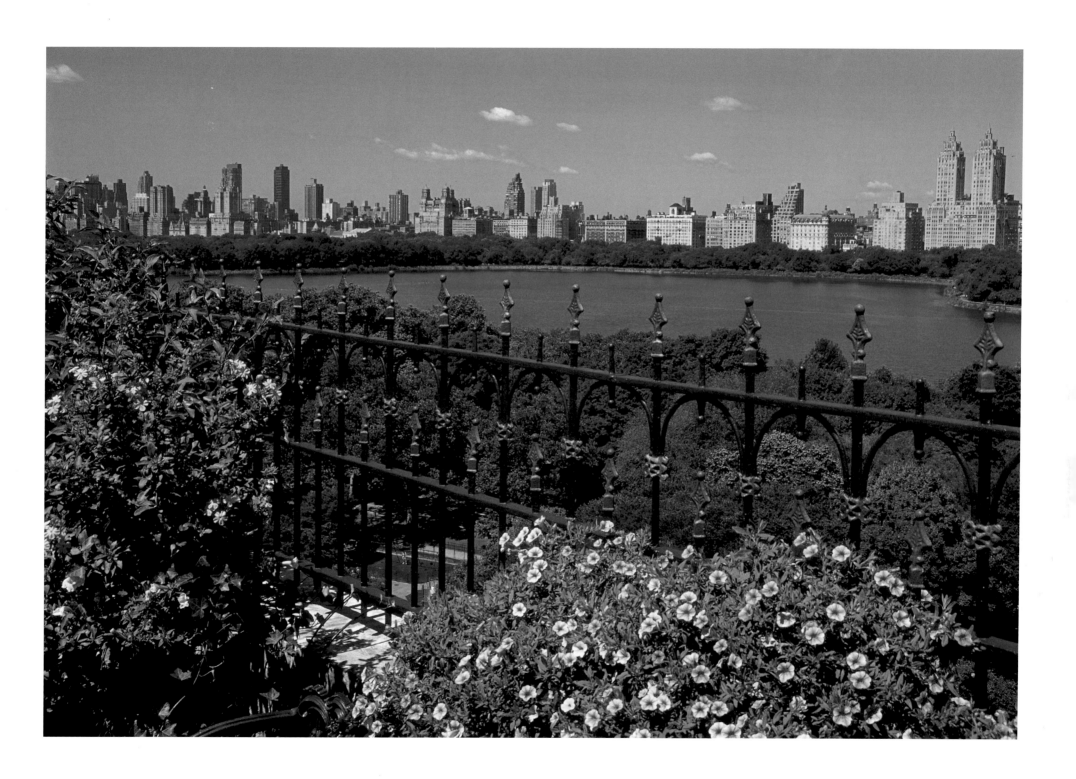

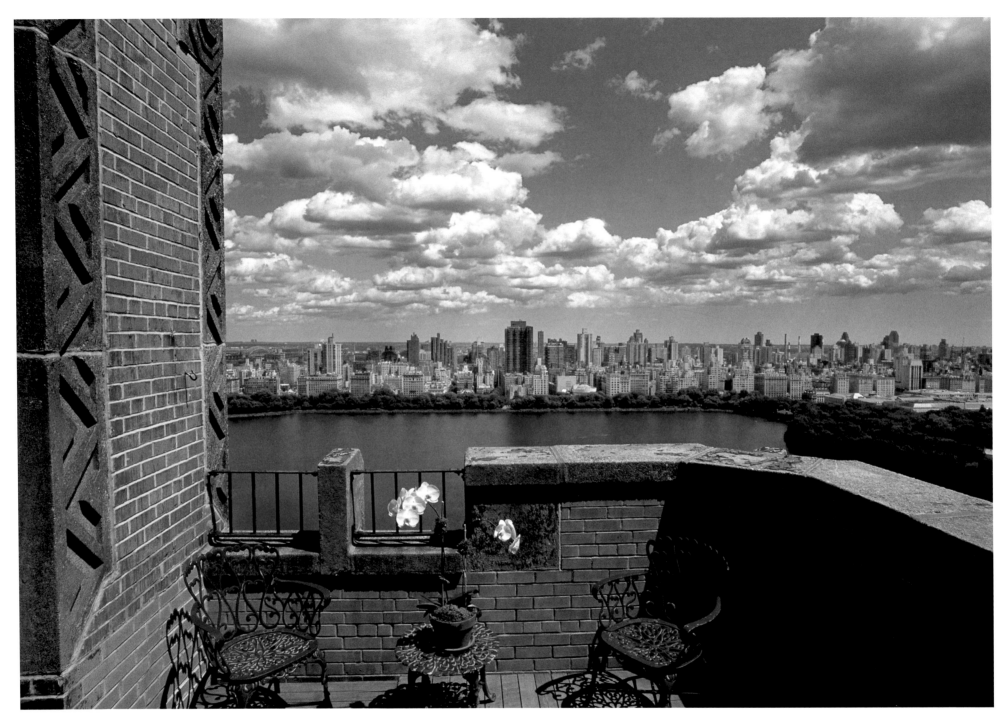

The Reservoir, viewed from a high terrace on Central Park West.

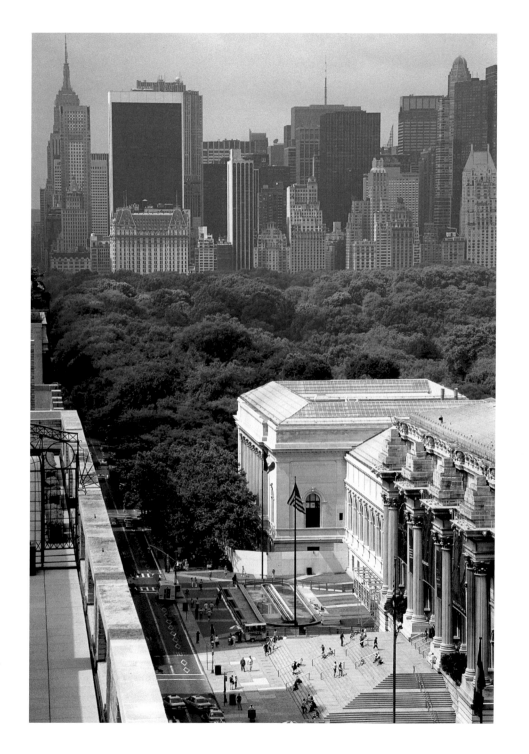

The Metropolitan Museum of Art with Central Park beyond, viewed from Fifth Avenue in the mid-80s.

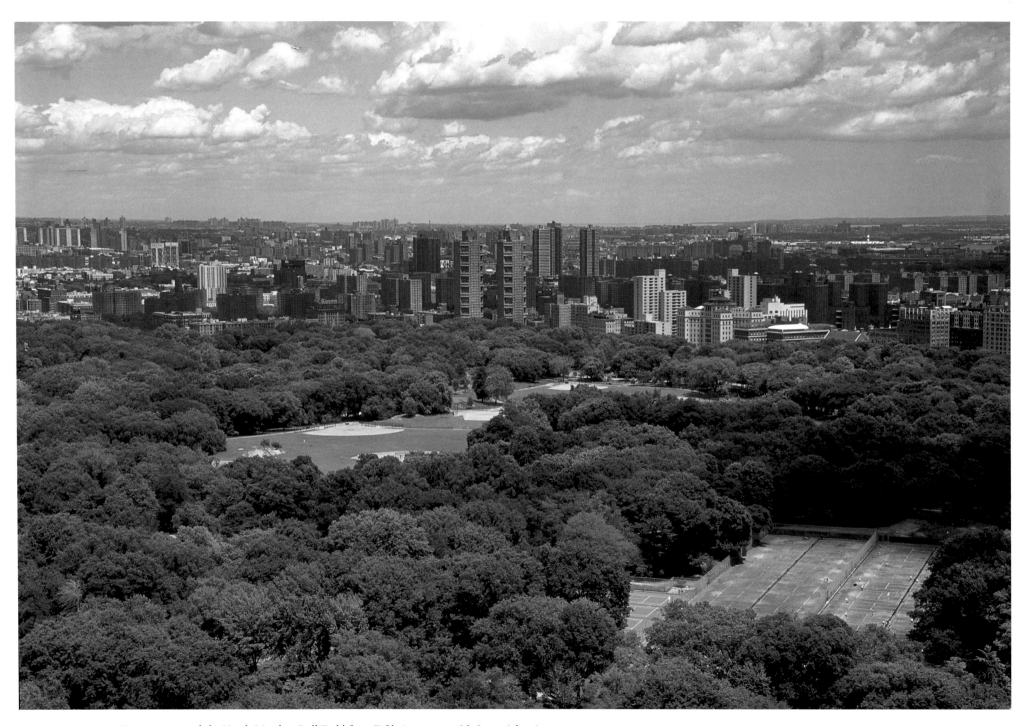

*Summer recreation: Tennis courts and the North Meadow Ball Field from Fifth Avenue at 96th Street (above);
activity on a ball field on the Great Lawn, seen from a window in Belvedere Castle (opposite).*

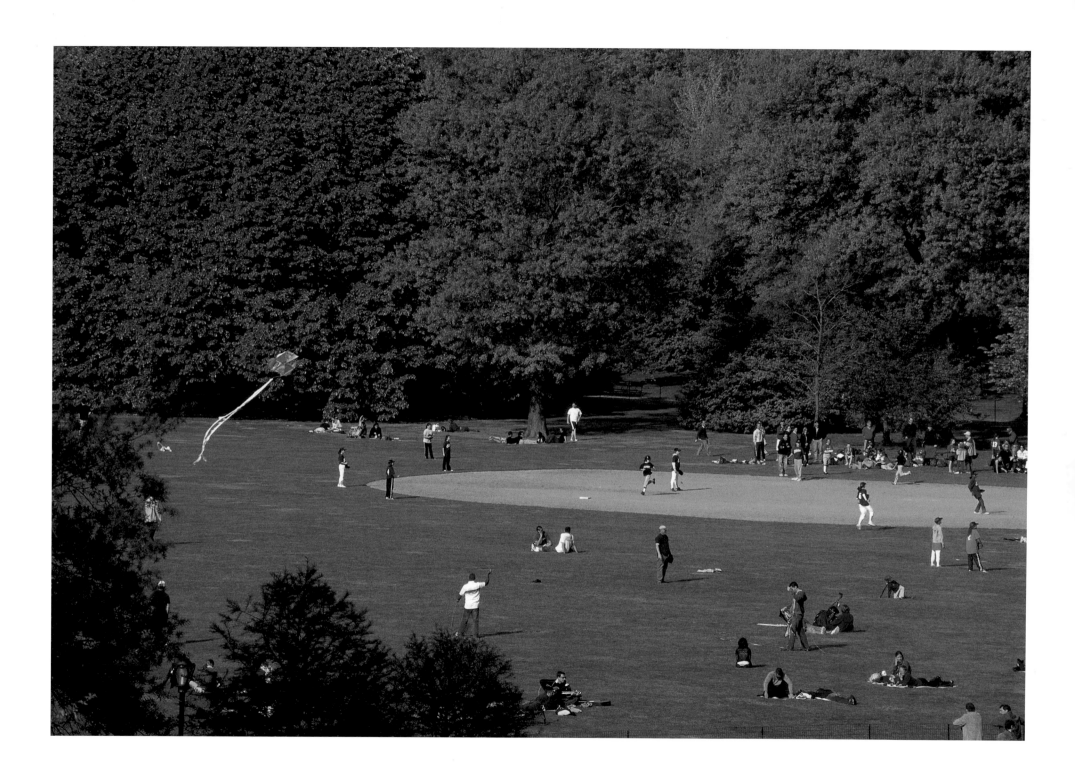

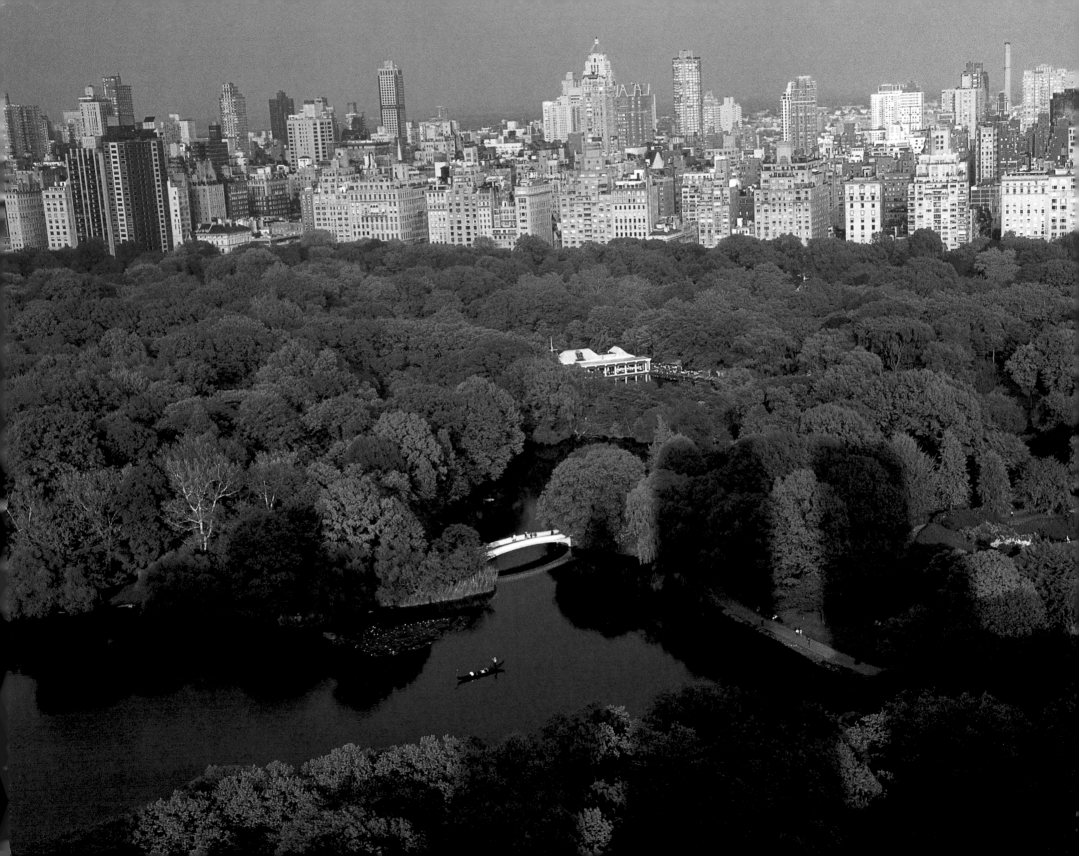

"Central Park is my clock, particularly on a summer day. The trees mysteriously appear in waves that cross the Park. They catch the light and tell the time. In early morning the green is dark and dramatic. Then it begins to pale across the Park as the sun rises, and when the pale green moves to my window I know it is noon. Then the colors reverse, pale to dark, until the Park is as blue as the night."

MARY JANE POOL
Editor and Writer

The Lake, Bow Bridge, and Loeb Boathouse, viewed from Central Park West in the 70s.

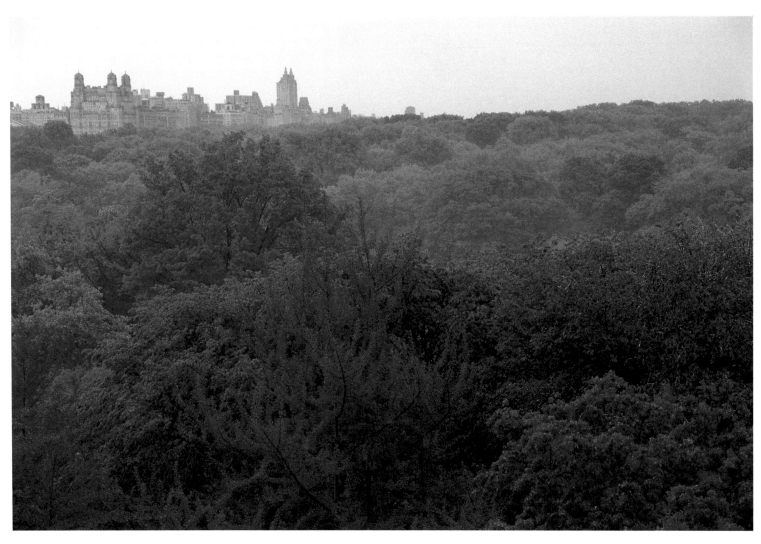

View in fog from Central Park South.

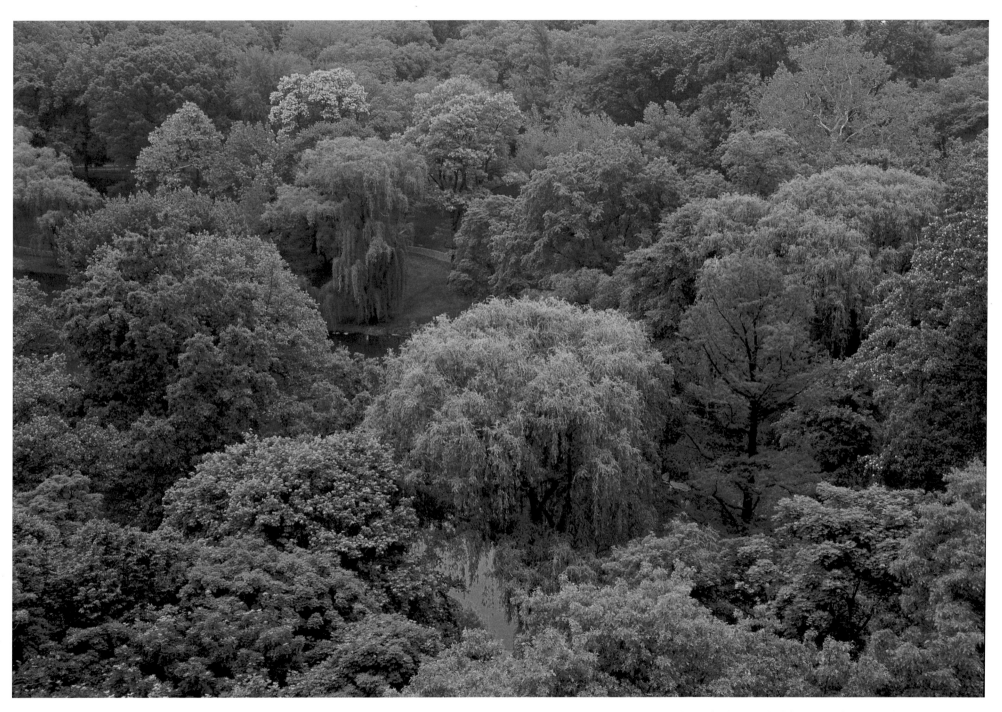

Willows, maples, and sweetgums at the Pool, photographed from 102nd Street and Central Park West.

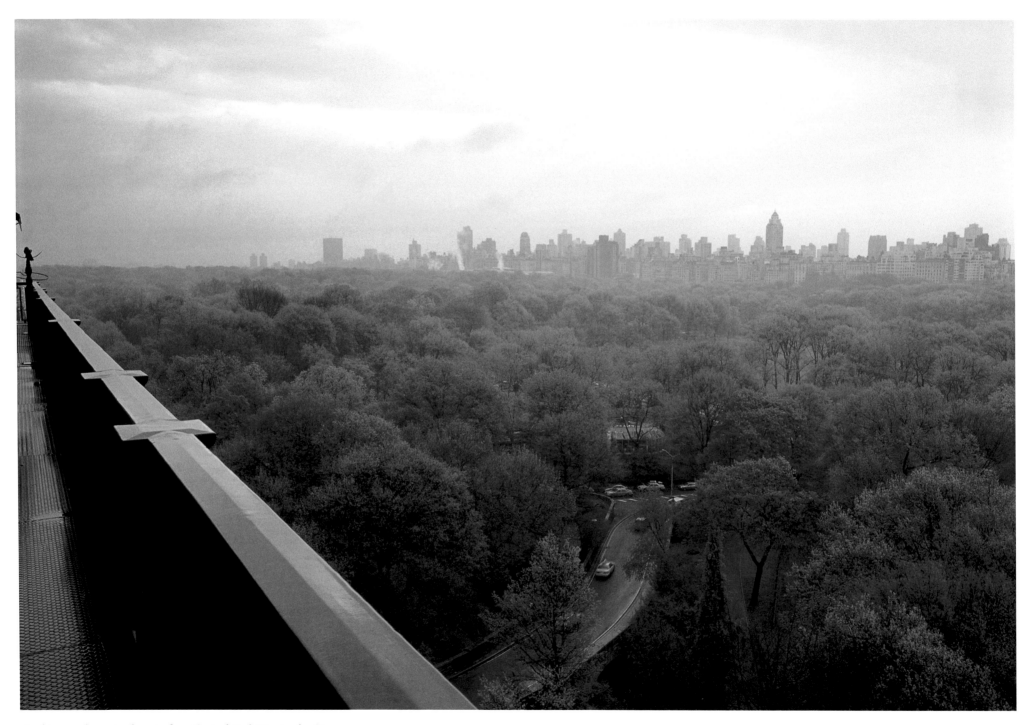

Looking northwest in the rain from Central Park West in the 60s.

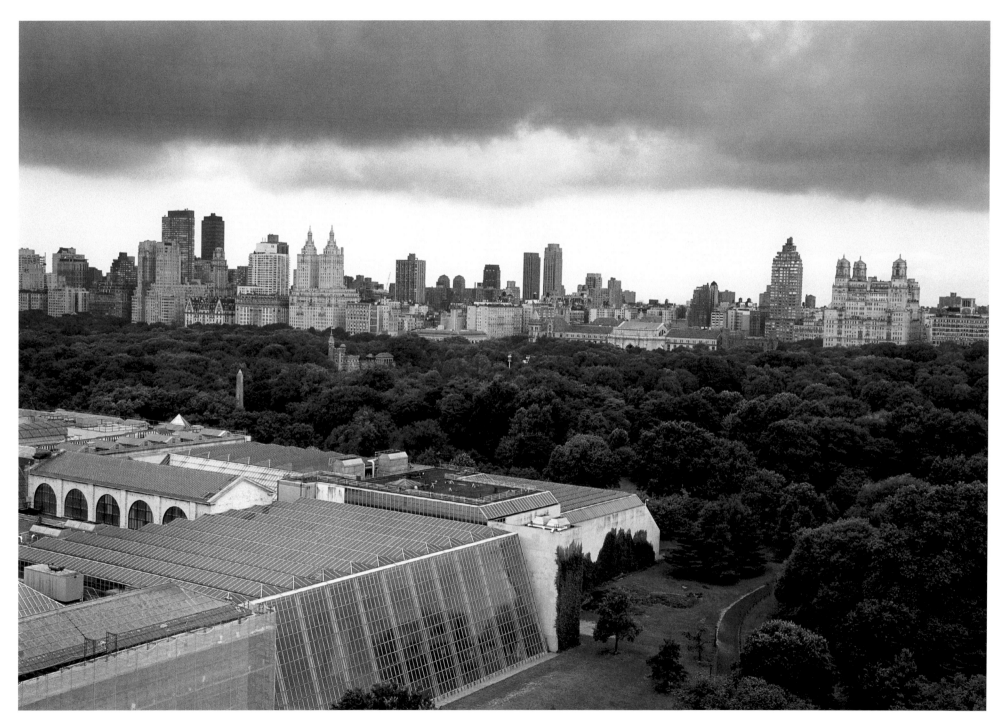

An ominous sky over Central Park and the Metropolitan Museum of Art, seen from a penthouse on Fifth Avenue in the mid-80s.

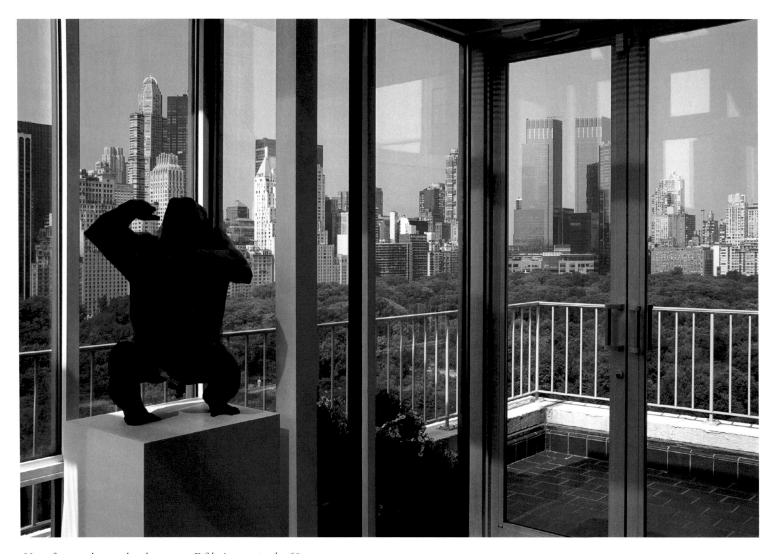

View from a glass-enclosed room on Fifth Avenue in the 60s

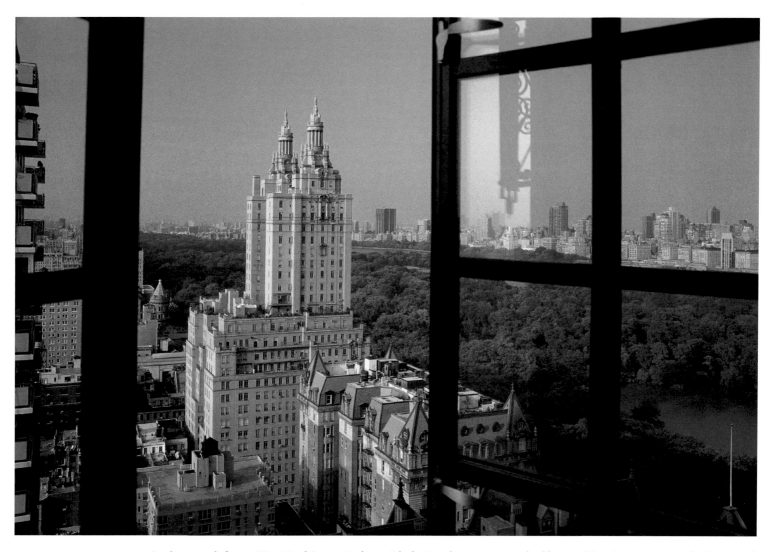

Looking north from a West 72nd Street window, with the Langham apartment building and San Remo towers in the foreground.

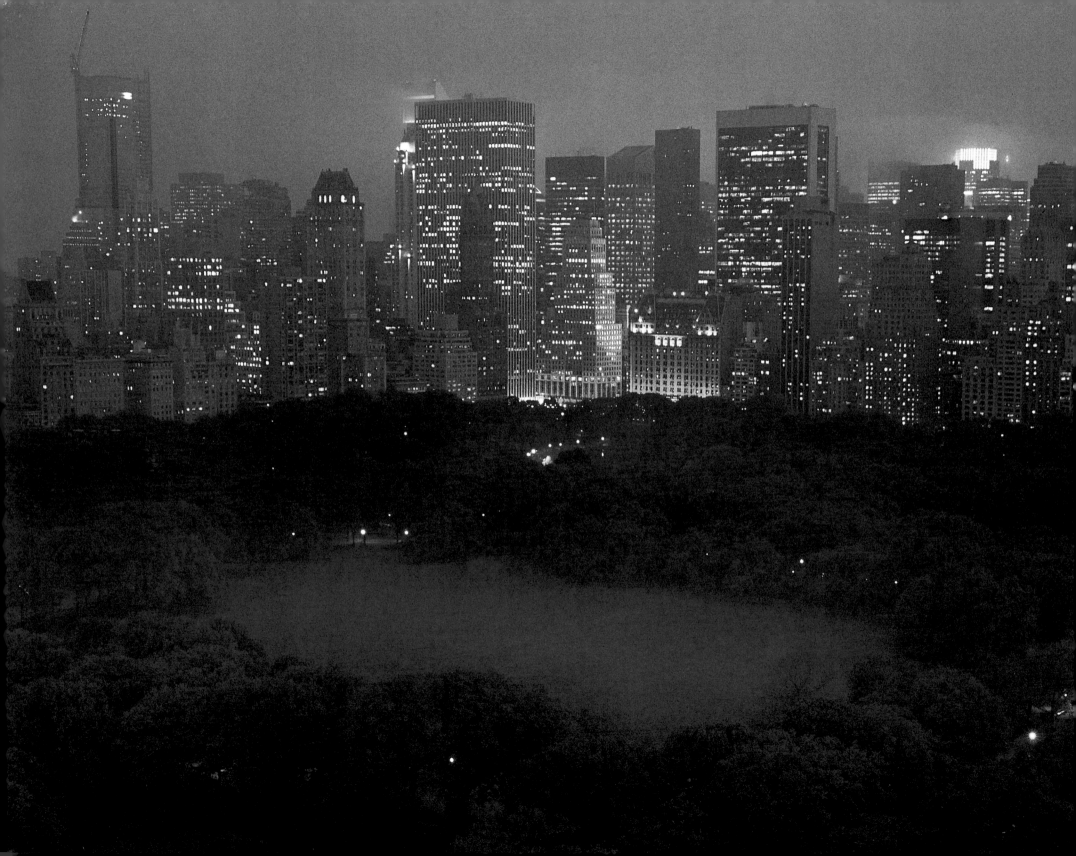

"*There are times when I look South across the Sheep Meadow and feel nothing less than awe that I have ended up here and that every day the pleasures of the city are mine and that there is so much to look forward to in the rest of the day. What an odd thing—for so urban a man to love a relatively small plot of nature so much.*"

DAVID HALBERSTAM
Author and Journalist

View south at dusk to the 15-acre Sheep Meadow with the skyline of Central Park South behind, from Central Park West in the 70s.

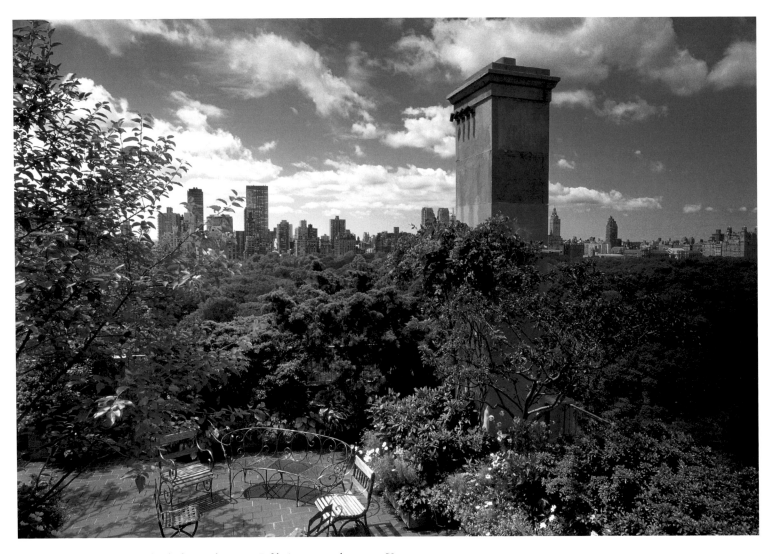

Looking down to the lower level of a penthouse on Fifth Avenue in the upper 60s.

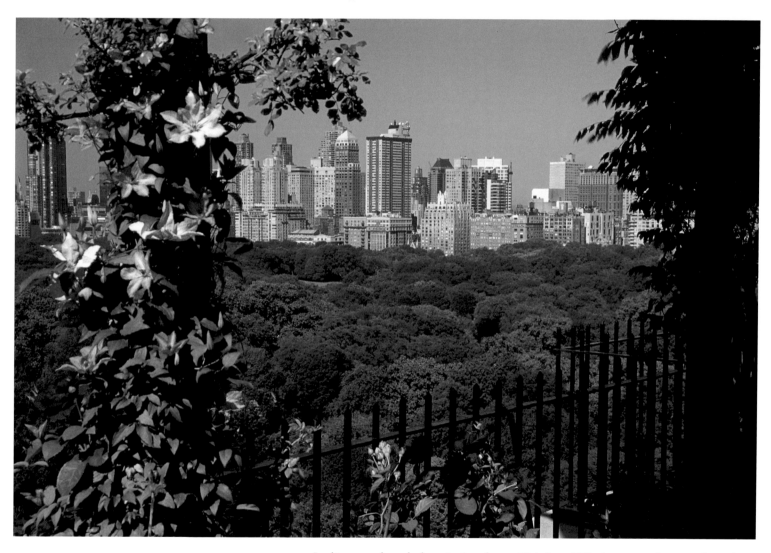

Looking west through clematis vines from a 20th-floor, Fifth Avenue penthouse in the mid-70s.

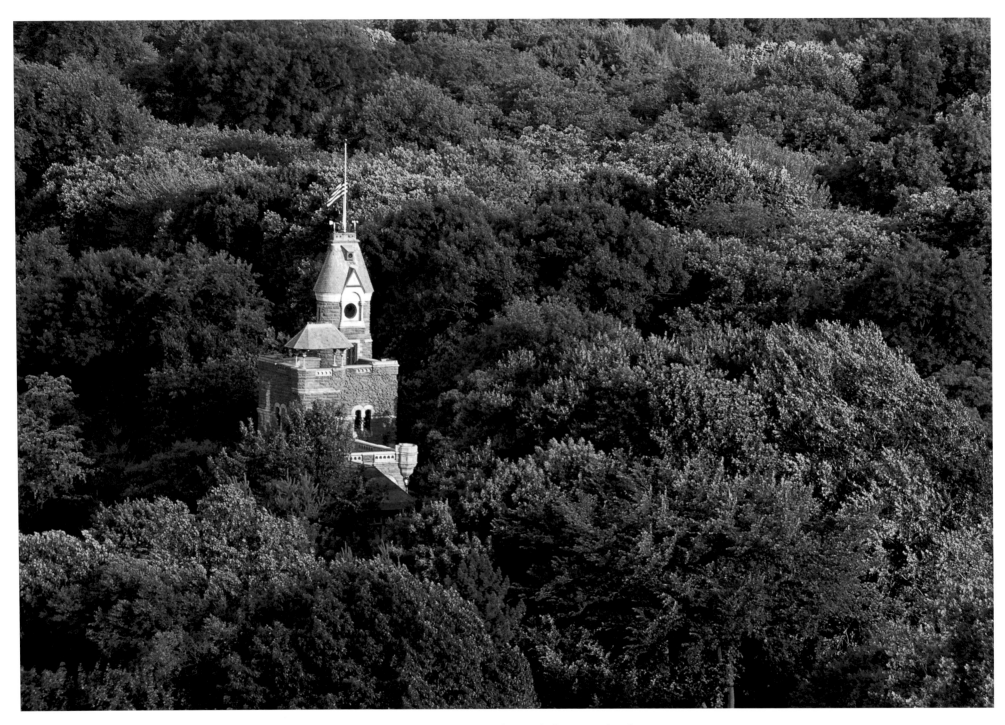

Belvedere Castle, the Victorian folly created by Calvert Vaux in 1869, photographed from a tower in the Beresford on Central Park West.

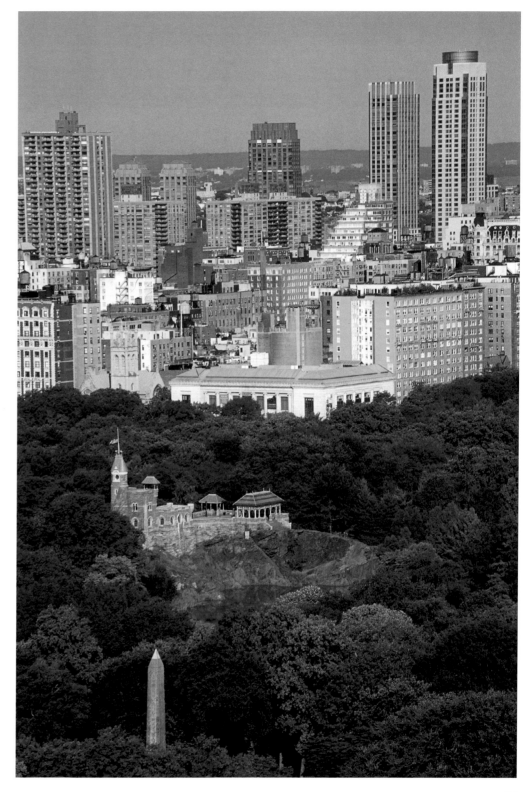

The Obelisk, often called Cleopatra's Needle, and Belvedere Castle appear in line with the New York Historical Society and other West Side buildings, seen from Fifth Avenue in the mid-70s.

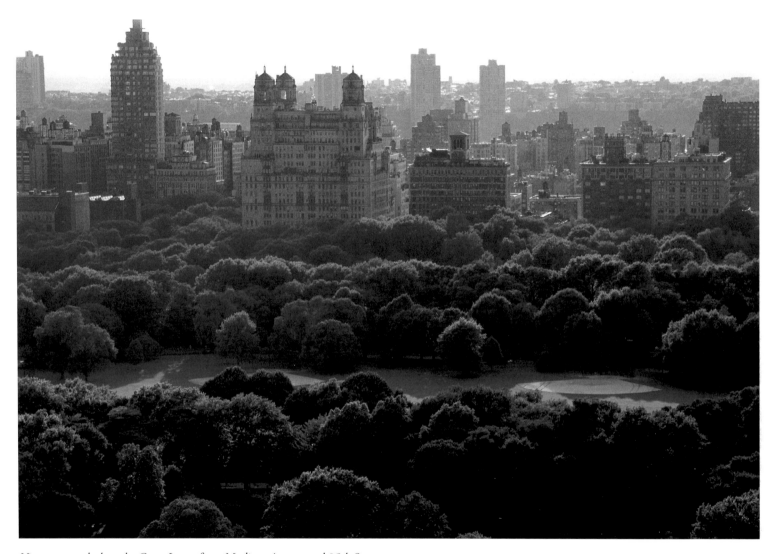

View west at dusk to the Great Lawn from Madison Avenue and 85th Street.

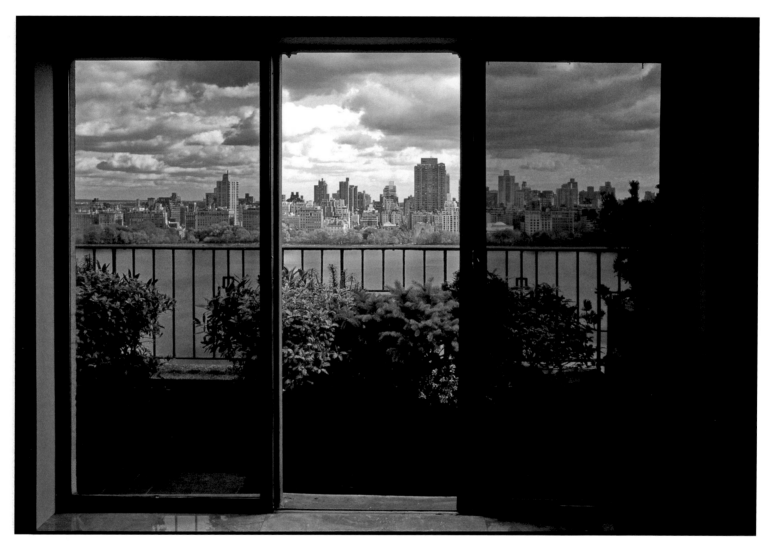

Looking to a terrace and the Reservoir beyond from a Central Park West apartment at 90th Street.

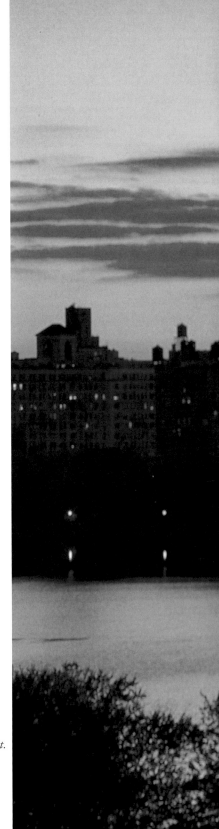

"*Our favorite moments are a splendid sunset, when the buildings across the Park reflect the shimmering gold or pink and their windows seem to dance in the sunlight. We wouldn't want to be in the penthouse of my building or on a lower floor; we love being at tree level, because we always feel we can reach out and touch the trees.*"

FELIX AND ELIZABETH ROHATYN

Sunset view of the Reservoir from Fifth Avenue at 96th Street.

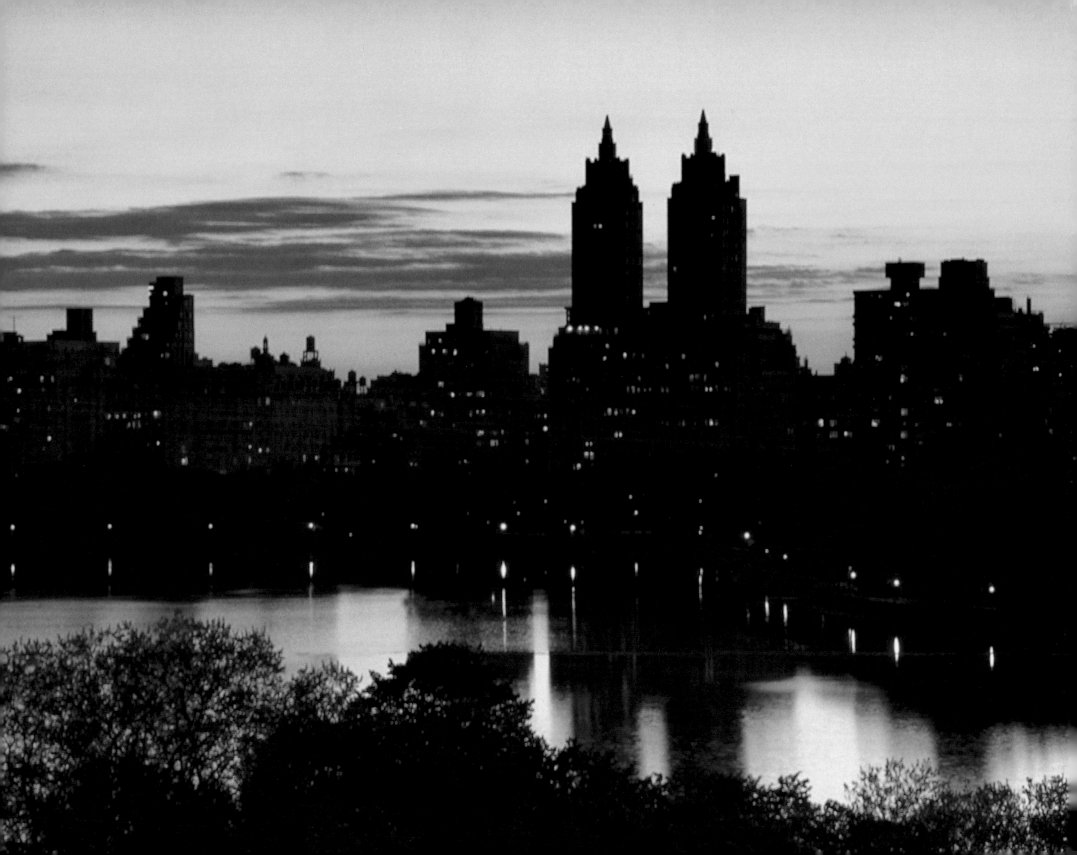

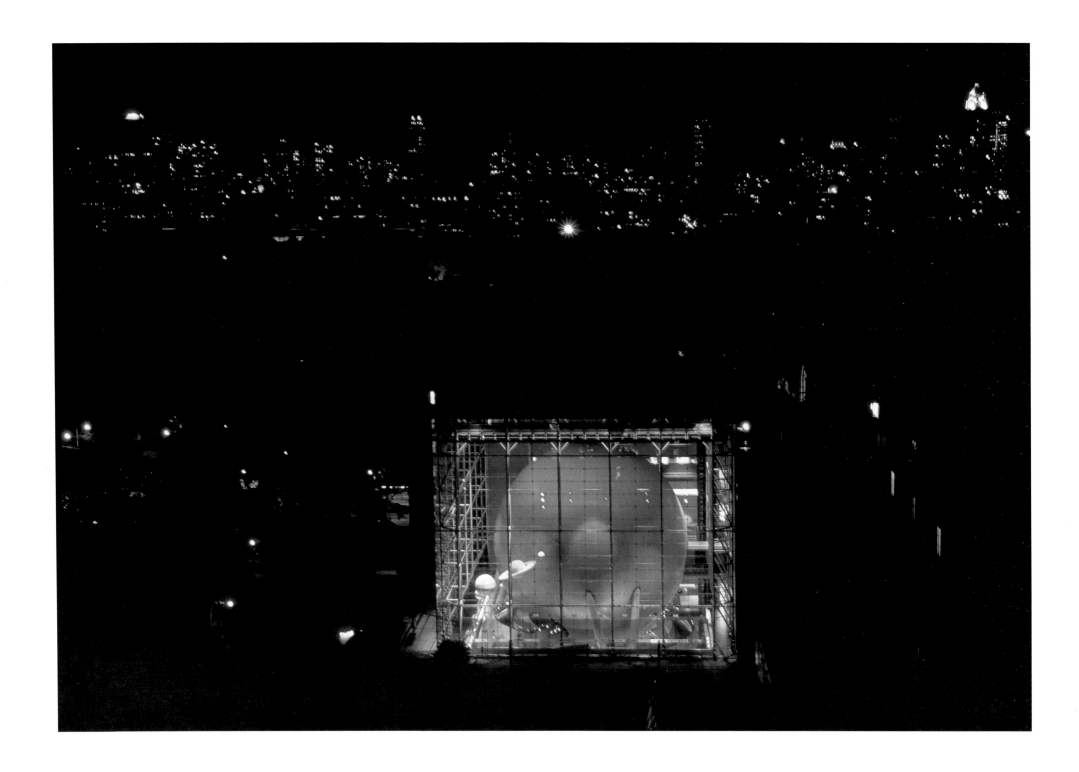

Central Park at night: The Rose Center for Earth and Space (opposite); fireworks following a concert on the Great Lawn (right), both viewed from West 79th Street near Columbus Avenue.

FALL

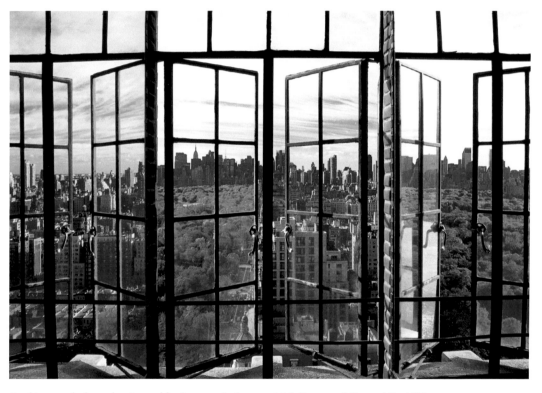

Looking south through mirrored bathroom windows on 90th Street and Central Park West.

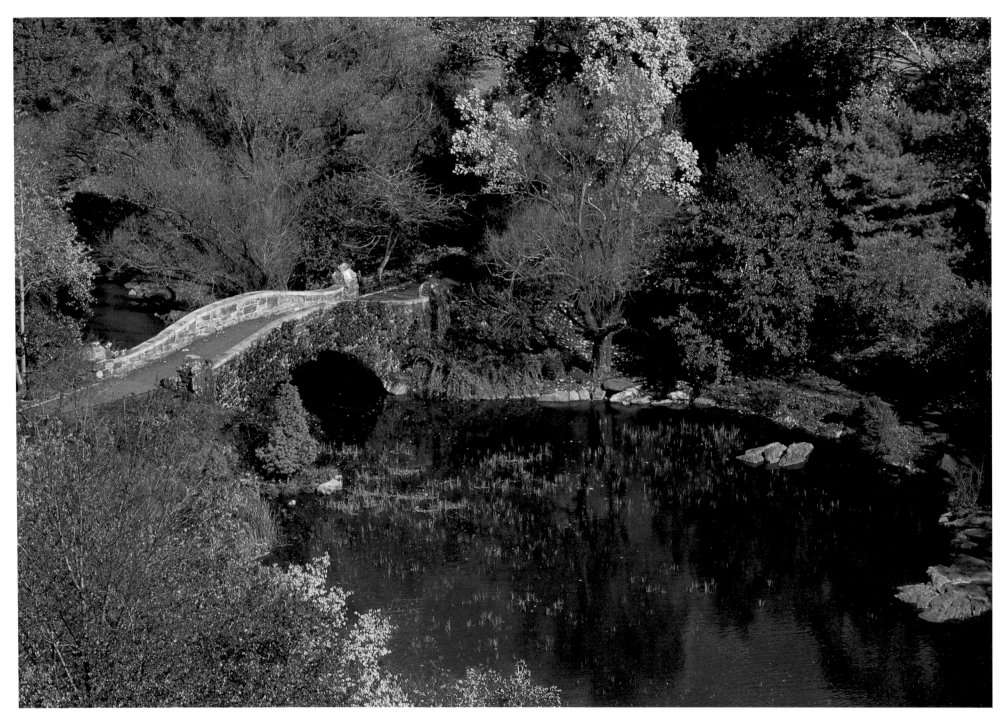

View of Gapstow Bridge from Central Park South near Sixth Avenue.

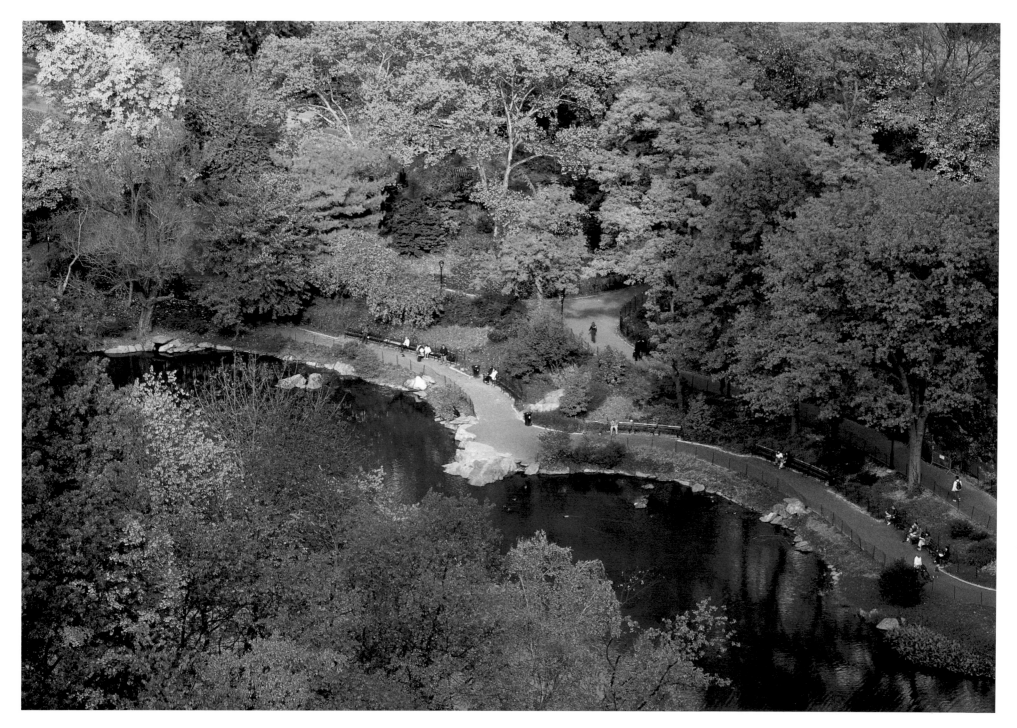

Southeast side of the Pond, viewed from Central Park South near Sixth Avenue.

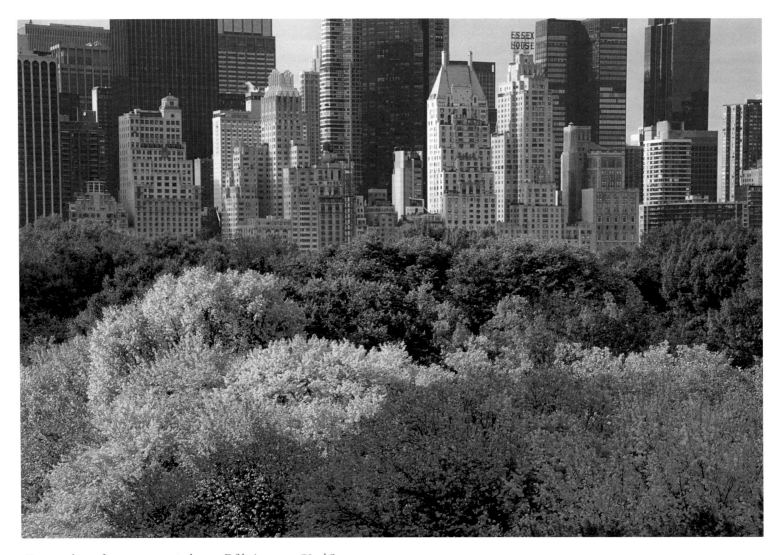

View southwest from a corner window on Fifth Avenue at 72nd Street.

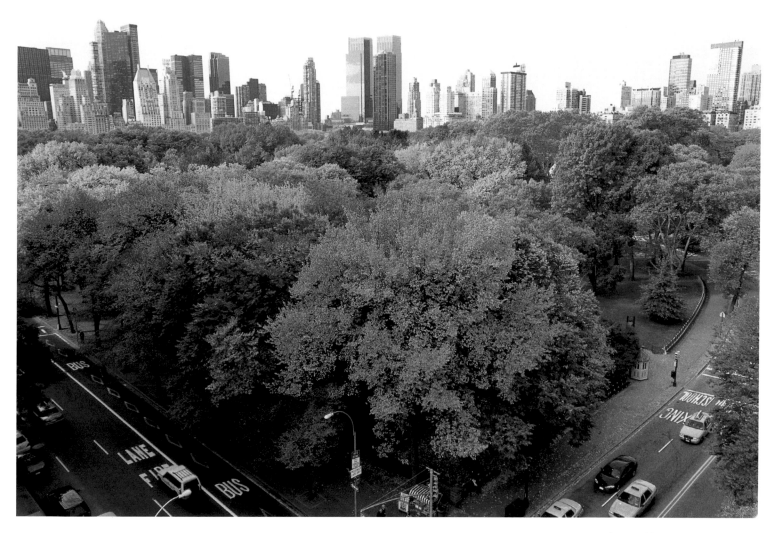

View west from Fifth Avenue in upper 60s.

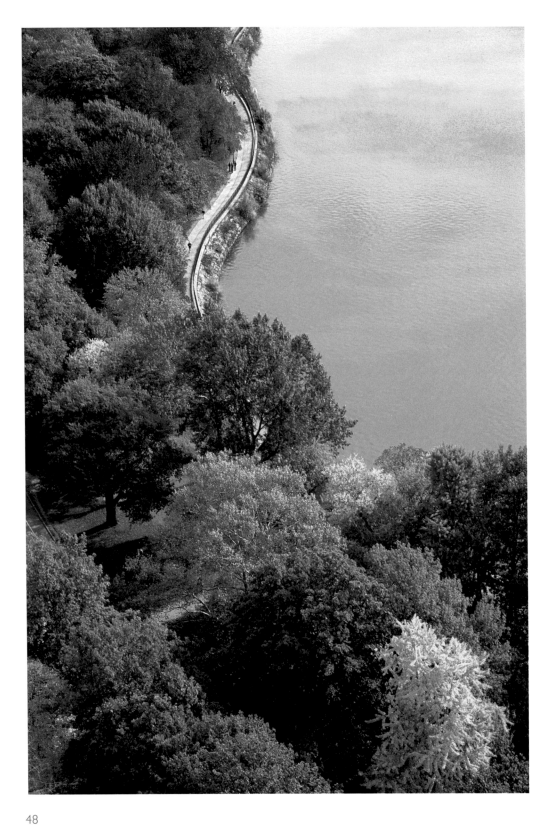

The shoreline of the Reservoir, seen from Central Park West at 90th Street.

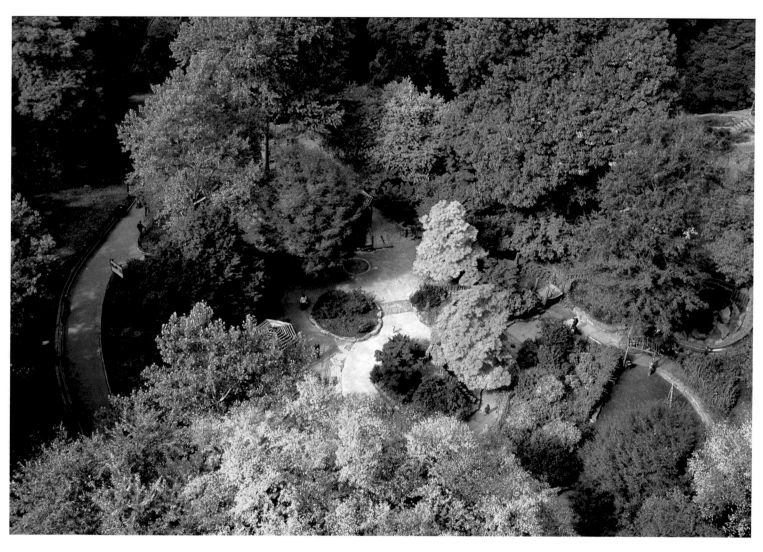

Looking down at the Billy Johnson Playground from Fifth Avenue and 69th Street.

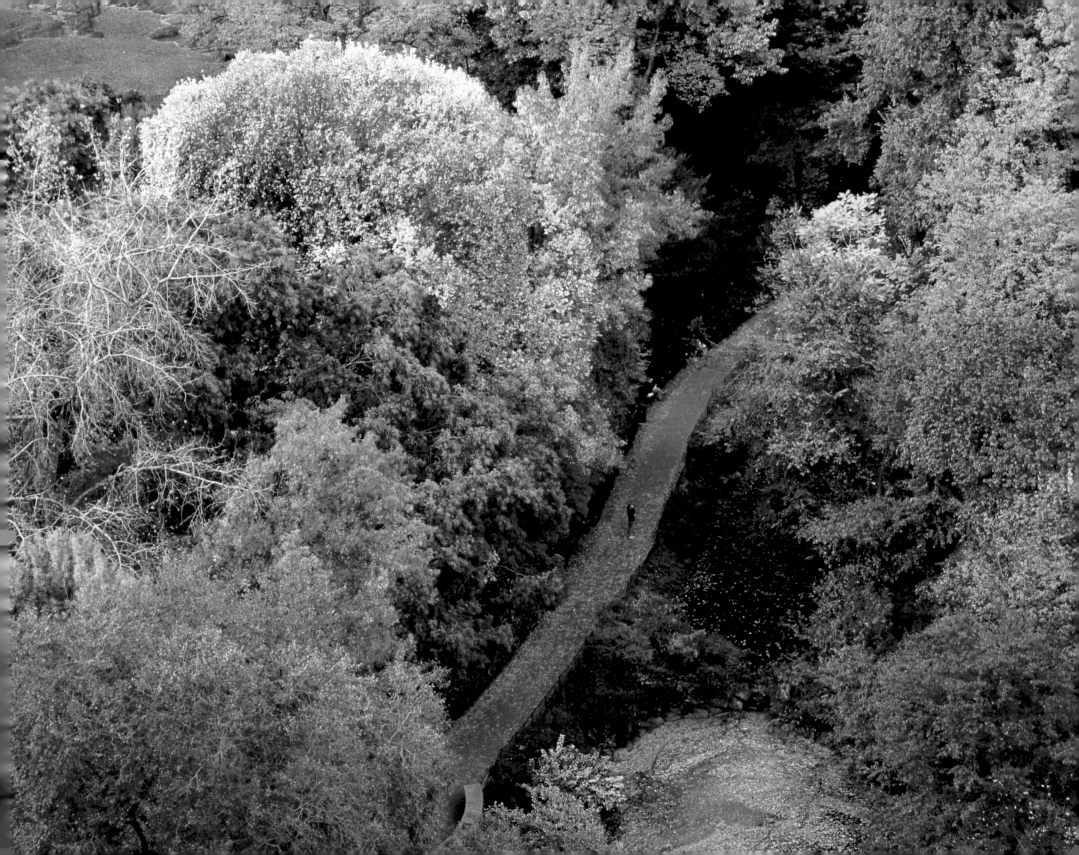

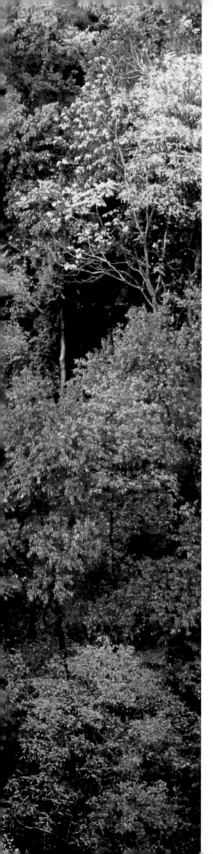

"*Looking out our windows to the Park each day is like seeing an ever-changing menu at the world's finest table. There is no greater feast for the eyes.*"

TIM AND NINA ZAGAT
Founders, *Zagat Survey*

Pathway along northwest side of the Pond, viewed from Central Park West at 90th Street.

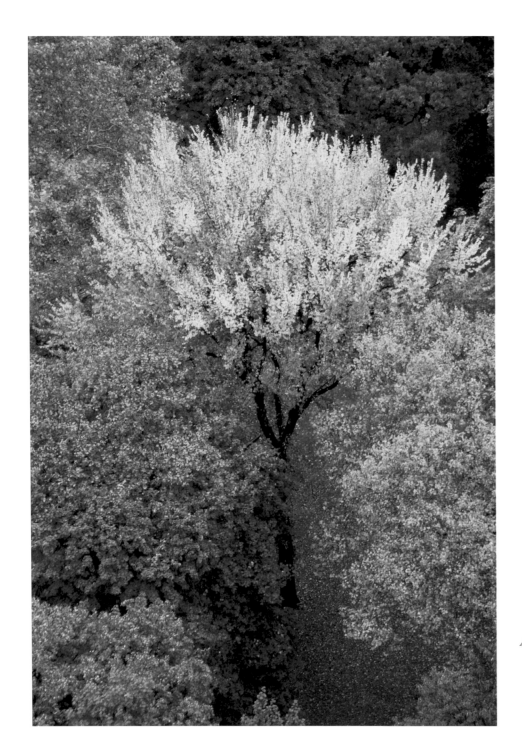

A maple, seen from a window on Central Park West.

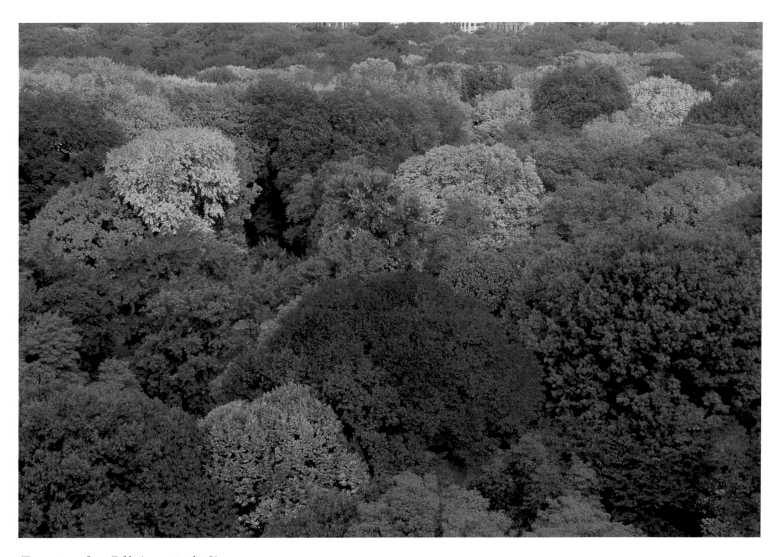

Treetop view from Fifth Avenue in the 60s.

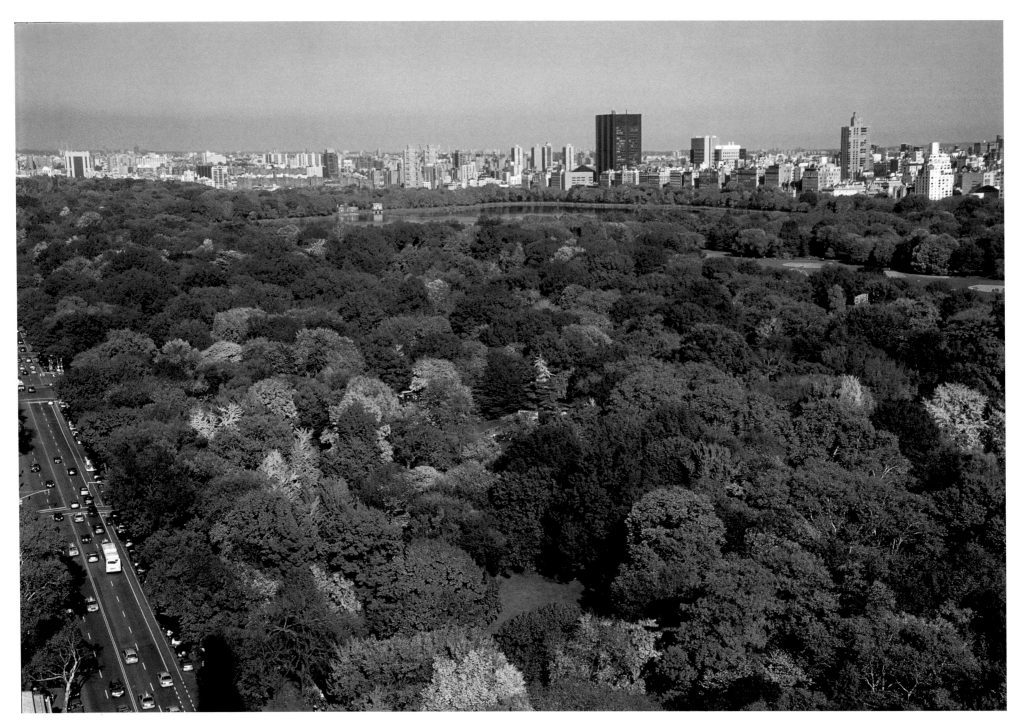

Landscape from Central Park West in the mid-70s.

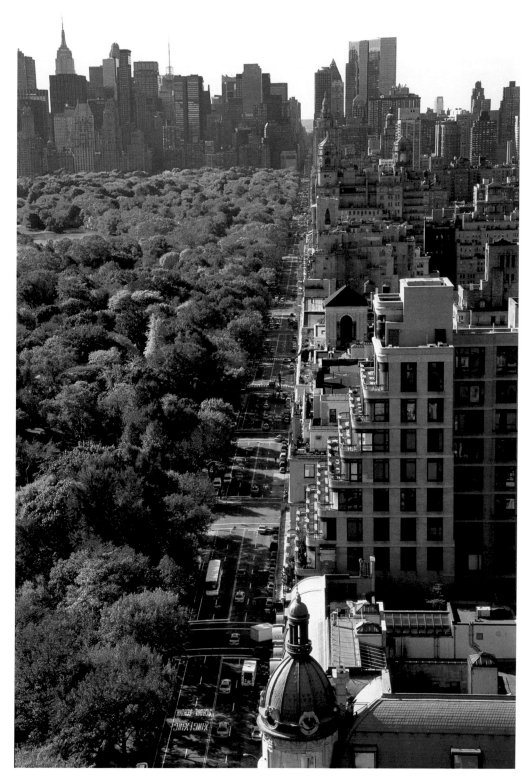

View down Central Park West from 90th Street.

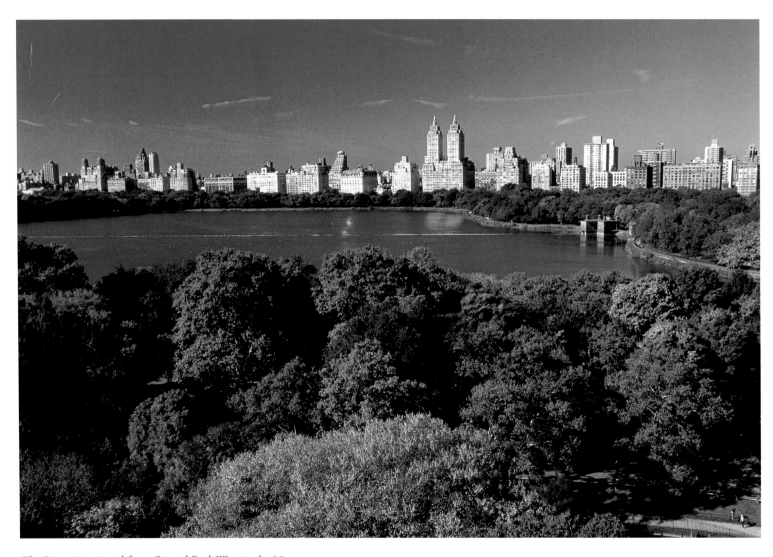

The Reservoir, viewed from Central Park West in the 90s.

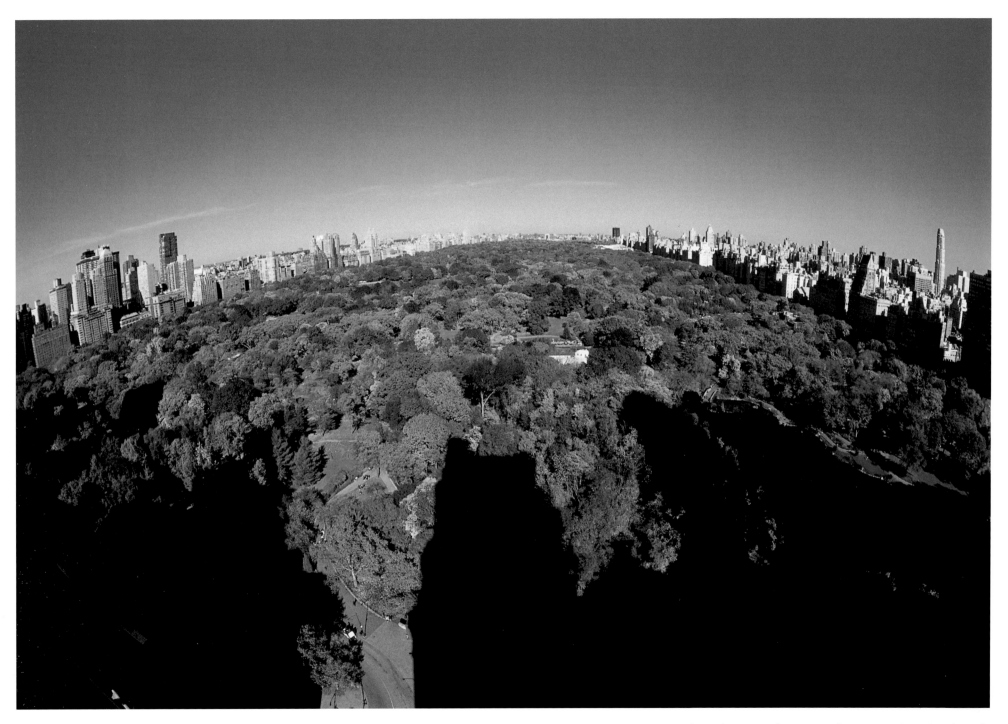

Panorama from The Ritz-Carlton New York terrace on Central Park South.

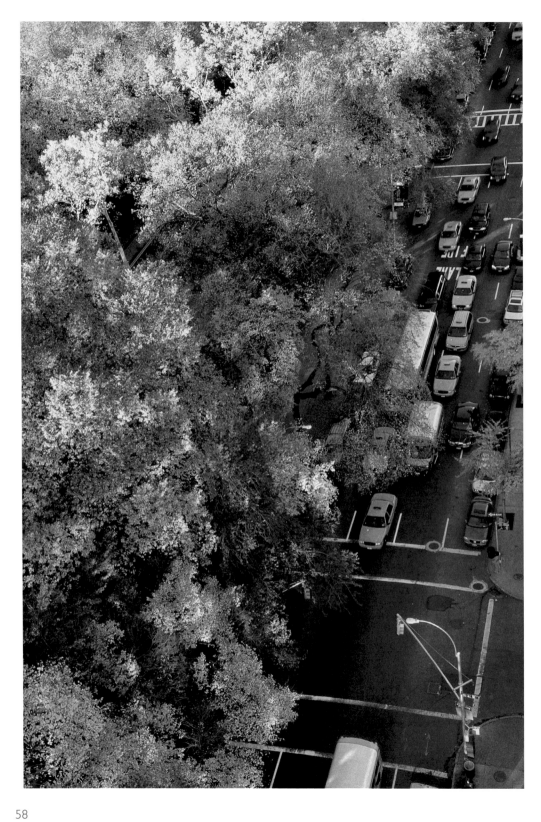

American elms along Fifth Avenue, seen from 107th Street.

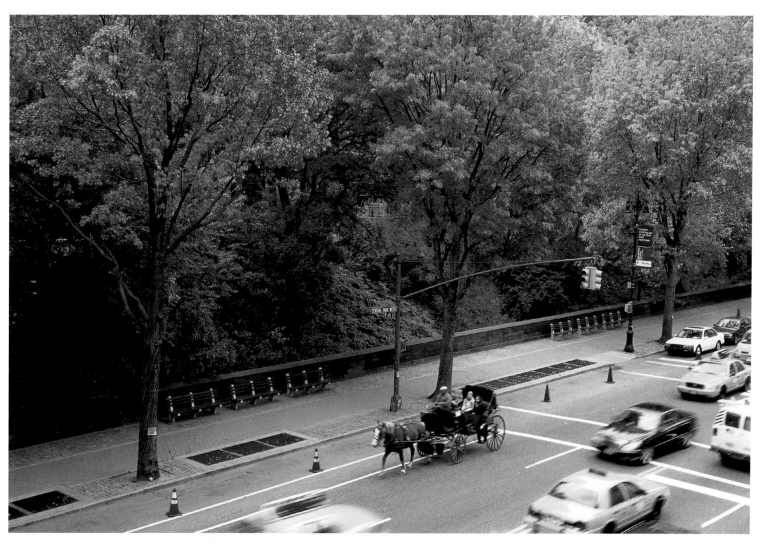

A horse-drawn carriage on Central Park West, seen from a 4th-floor window.

"I moved to an apartment with windows that look into the trees of Central Park, and while I love the fact that my view is lush and green in the summer, orange in the fall, and thin and almost colorless in the winter and spring…I set my desk to have my back to this view, since if I had to look at it all the time I know I would get nothing done because I knew it would distract me, or worse, eventually I'd stop noticing it. This way when I get up and walk to the window, looking out becomes an event. A view should not be wallpaper."

PAUL GOLDBERGER
Architecture Critic and Writer

from his introduction to *The City out My Window*,
Simon & Schuster, 2009

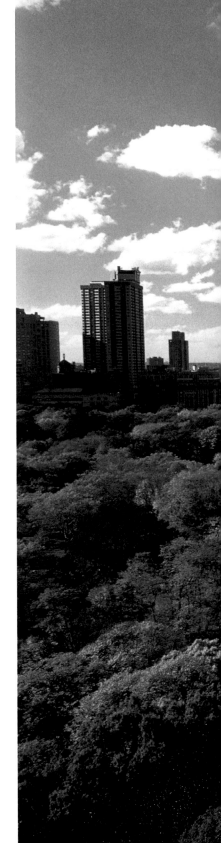

Landscape looking west from Fifth Avenue in the 60s.

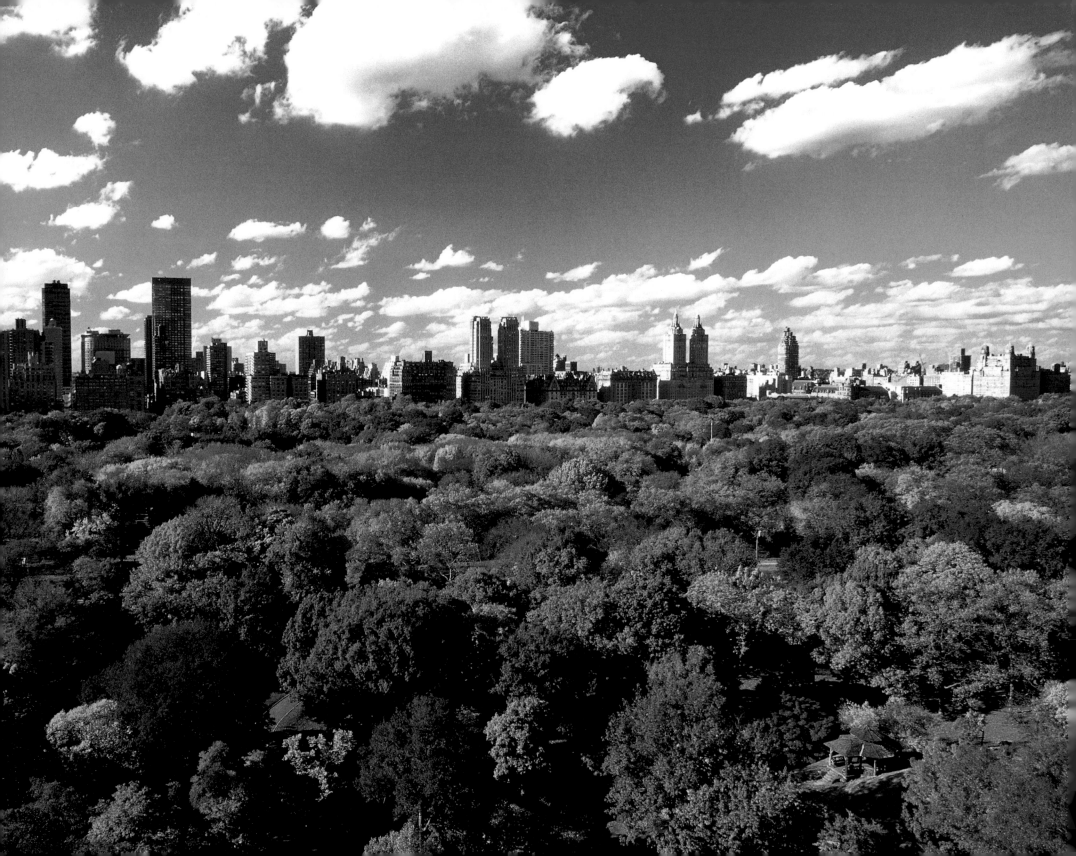

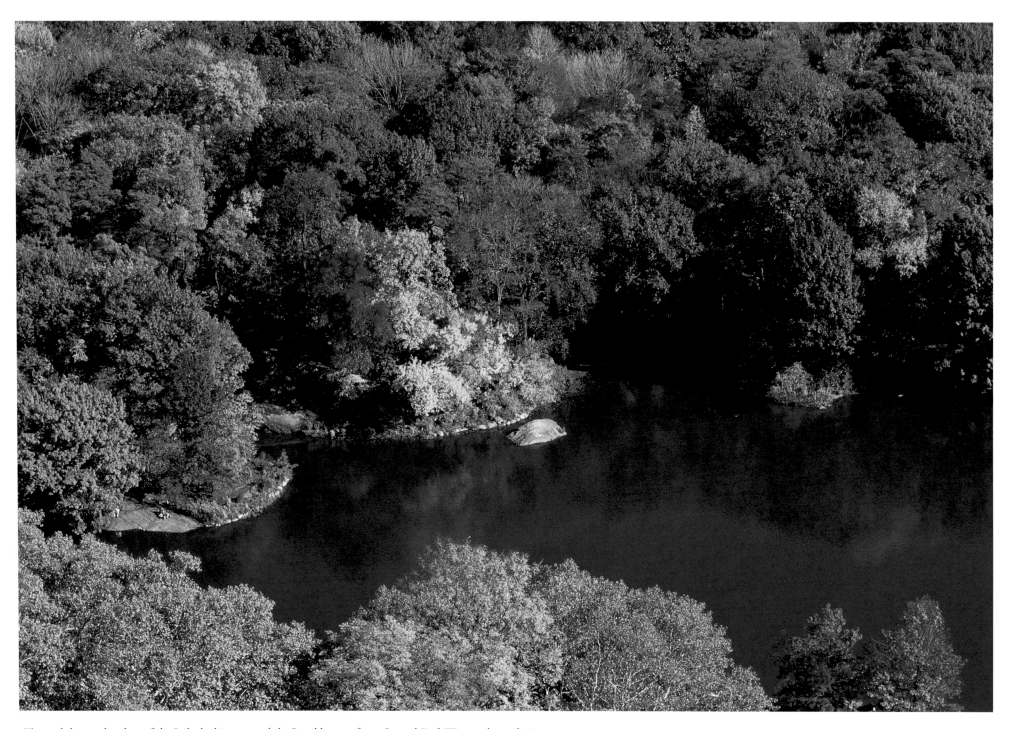

The undulating shoreline of the Lake looking toward the Ramble, seen from Central Park West in the mid-70s.

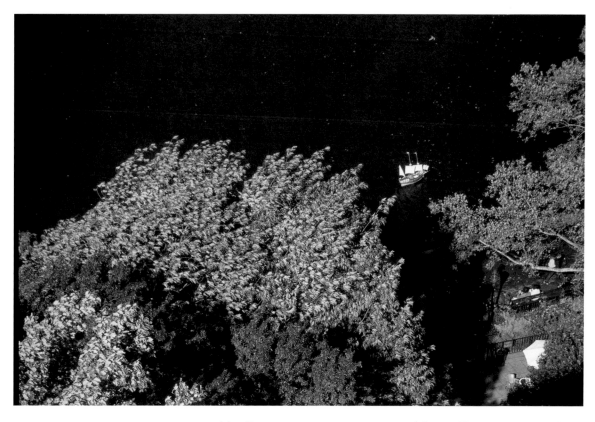

A model sailboat on Conservatory Water, viewed from Fifth Avenue in the mid-70s.

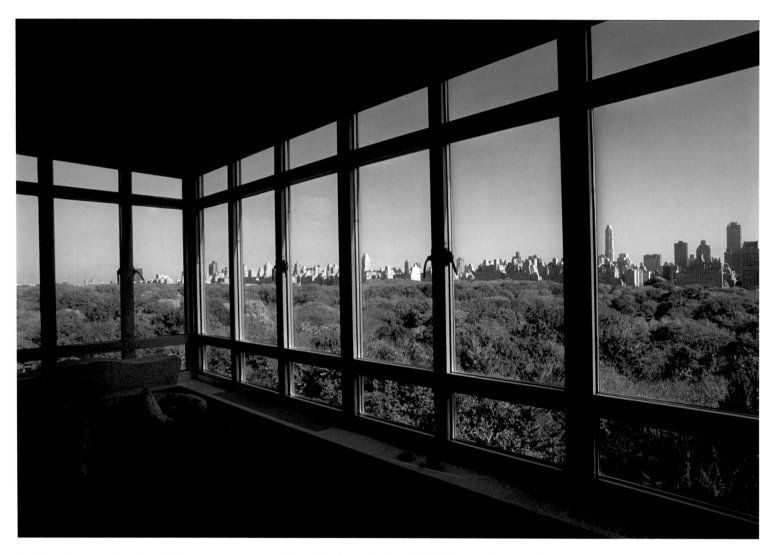

Window views north and south from one apartment on Central Park West in the mid-60s (above and opposite).

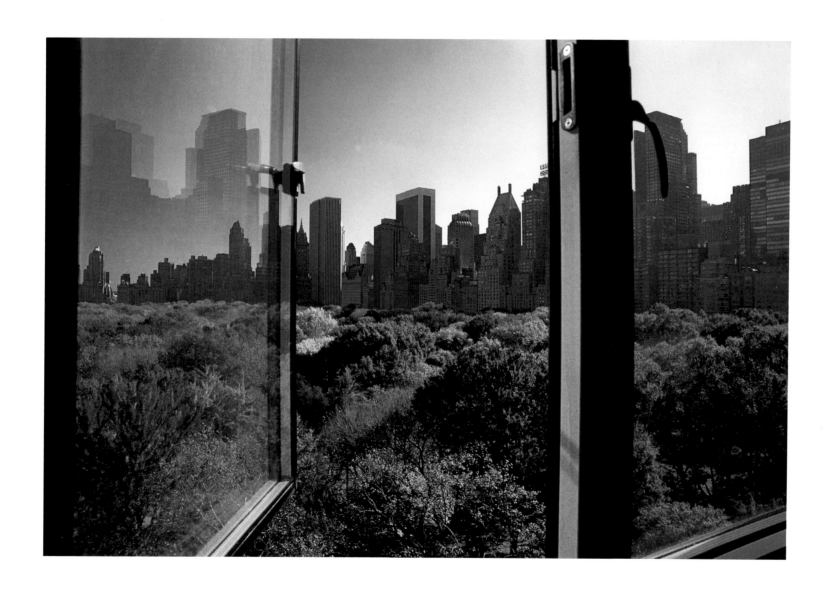

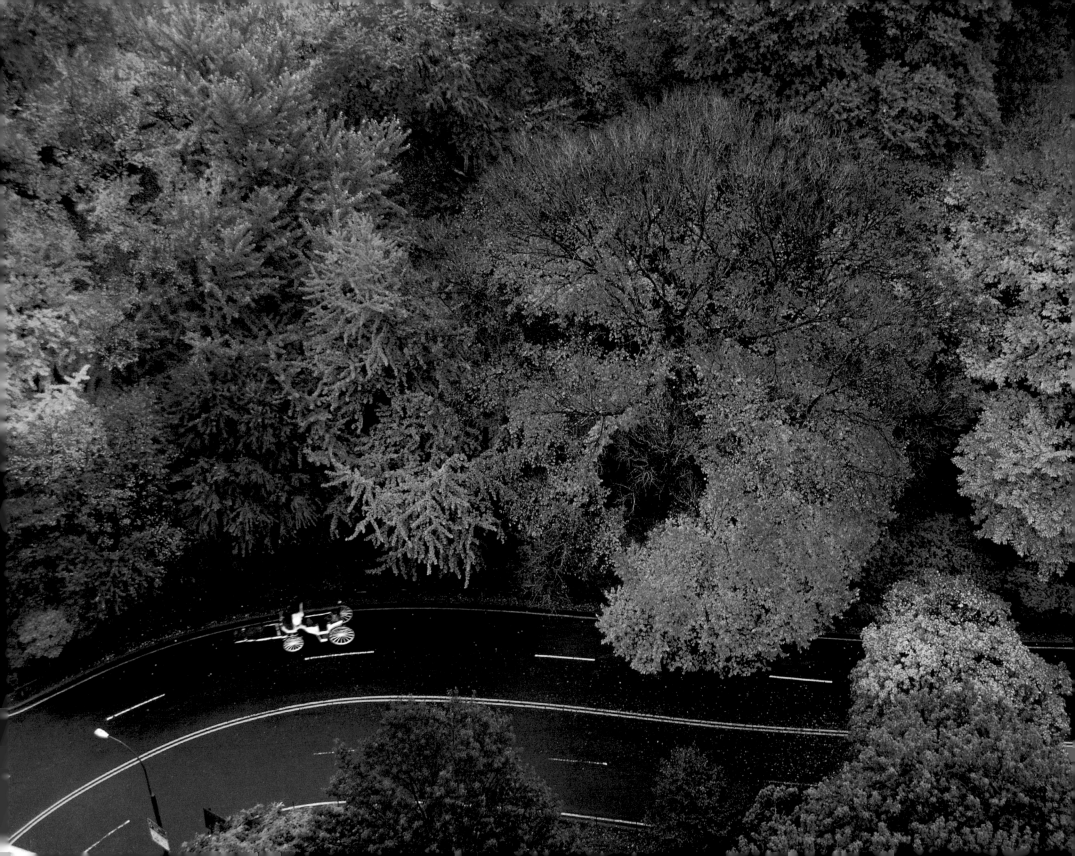

"Amid the blur of cabs and cars flying along the Upper West Side, the horse drawn carriage that I see out my window seems from a different time. Its slow steady pace has kept the carriage as sharply focused as the blaze of trees behind it, connecting it to the natural world as it was before gasoline, pollution, and the need for speed. Sometimes a glimpse of the past can help us find hope for the future."

TRUDY STYLER
Film Producer and Environmentalist

West Drive at 72nd Street with American elms and ginkgo trees at peak fall color, seen from a 29th-floor window on Central Park West.

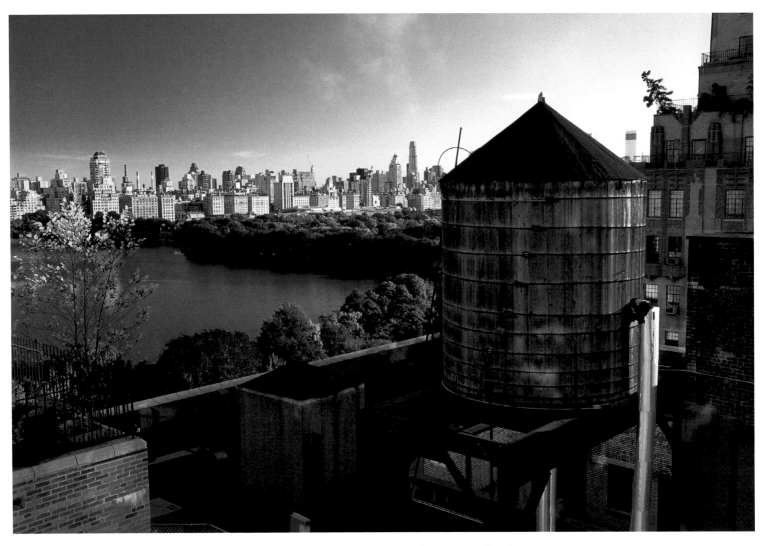

The Reservoir beyond a rooftop water tower, viewed through a 19th-floor kitchen window on Central Park West.

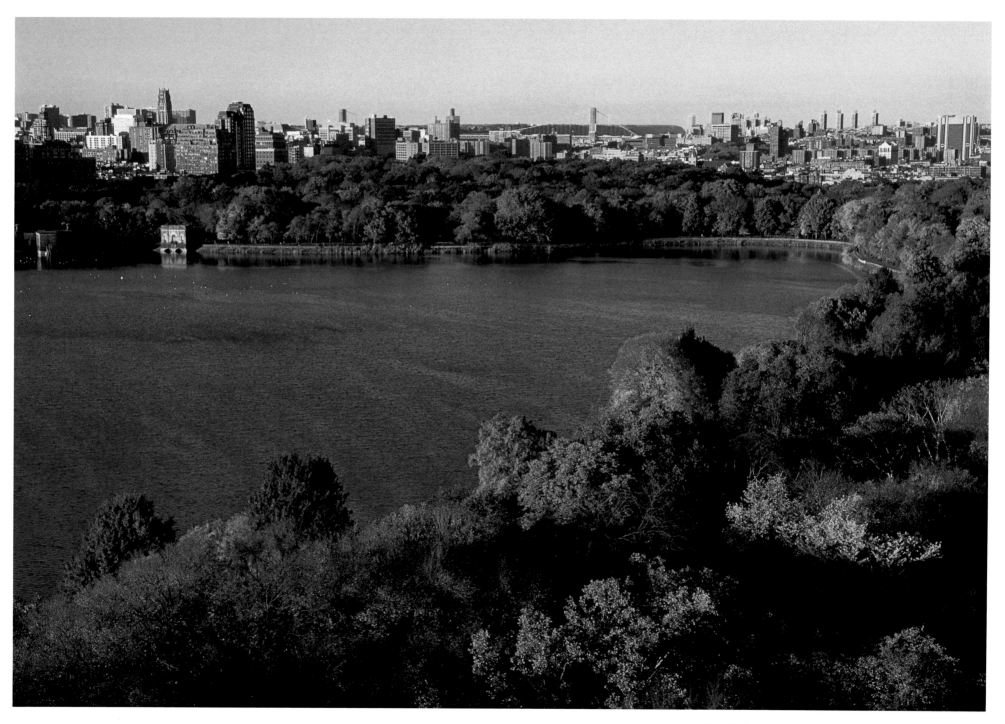

The Harlem Meer, viewed from Fifth Avenue at 86th Street.

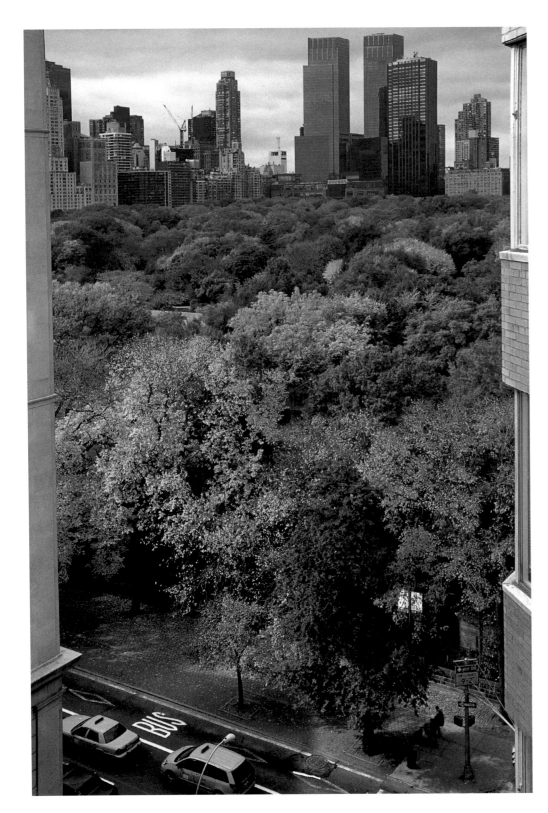

View looking west across the Park to the Time Warner Center from Fifth Avenue in the 60s.

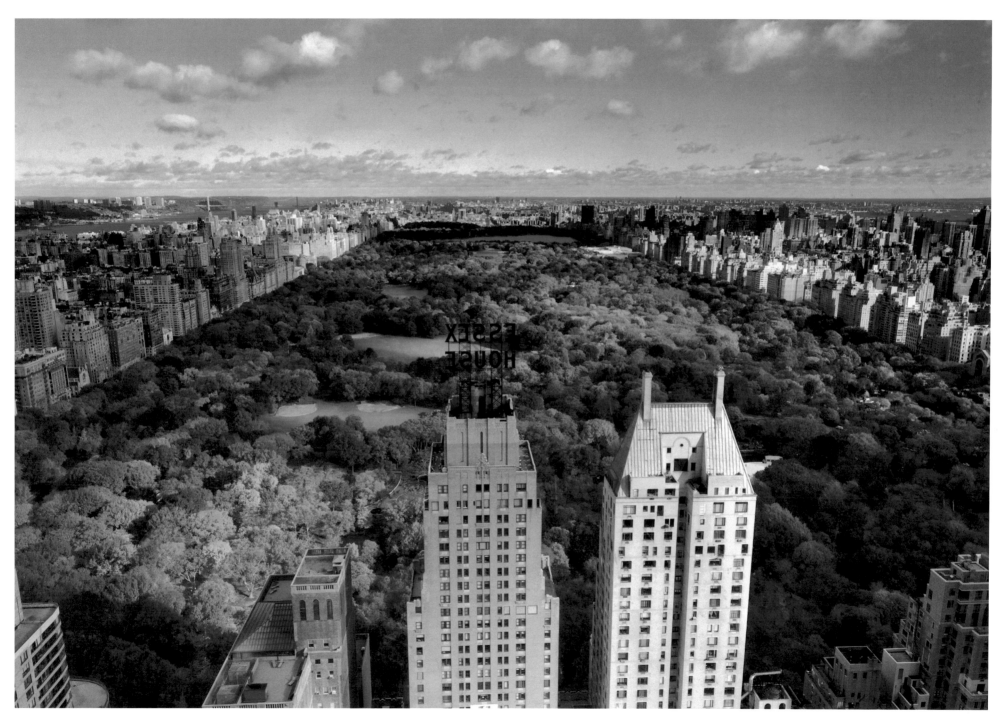

Landscape from office window on 57th Street near Seventh Avenue.

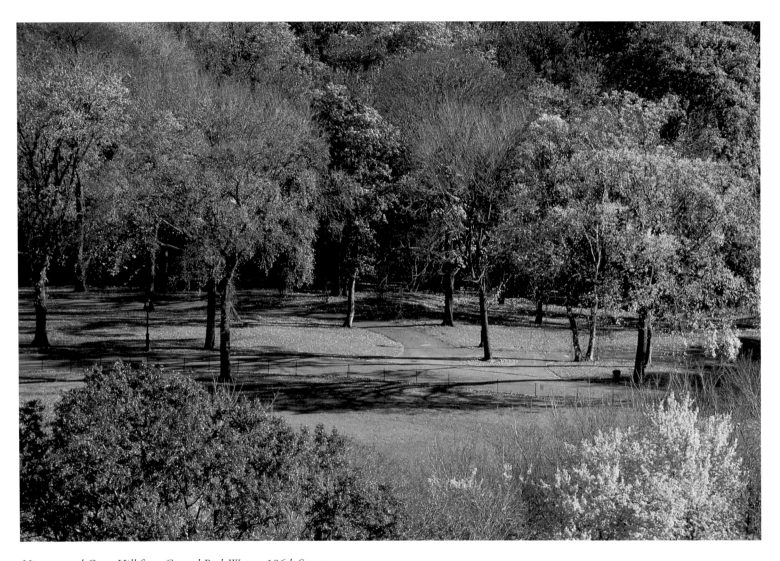

View toward Great Hill from Central Park West at 106th Street.

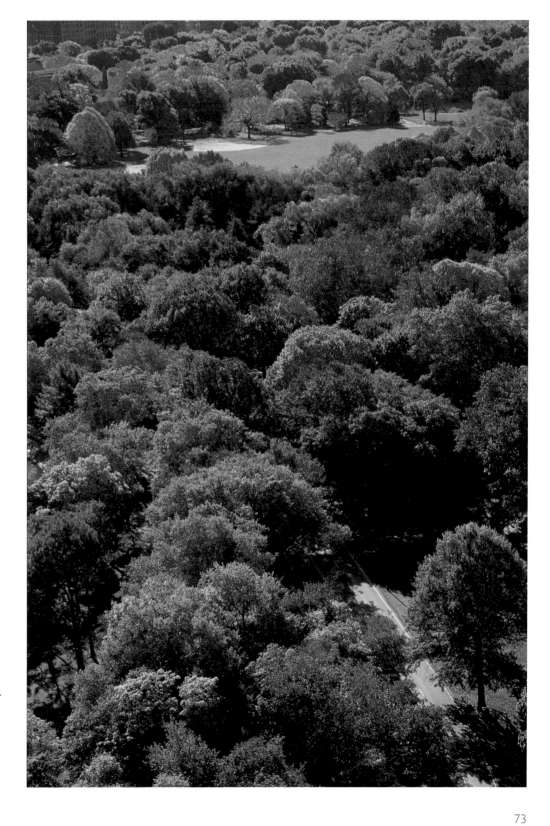

Looking over North Meadow from Central Park West at 91st Street.

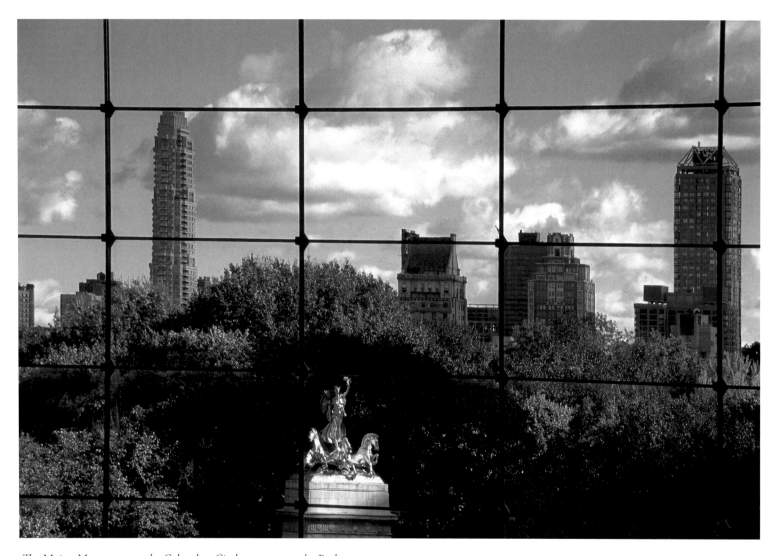

The Maine Monument at the Columbus Circle entrance to the Park.

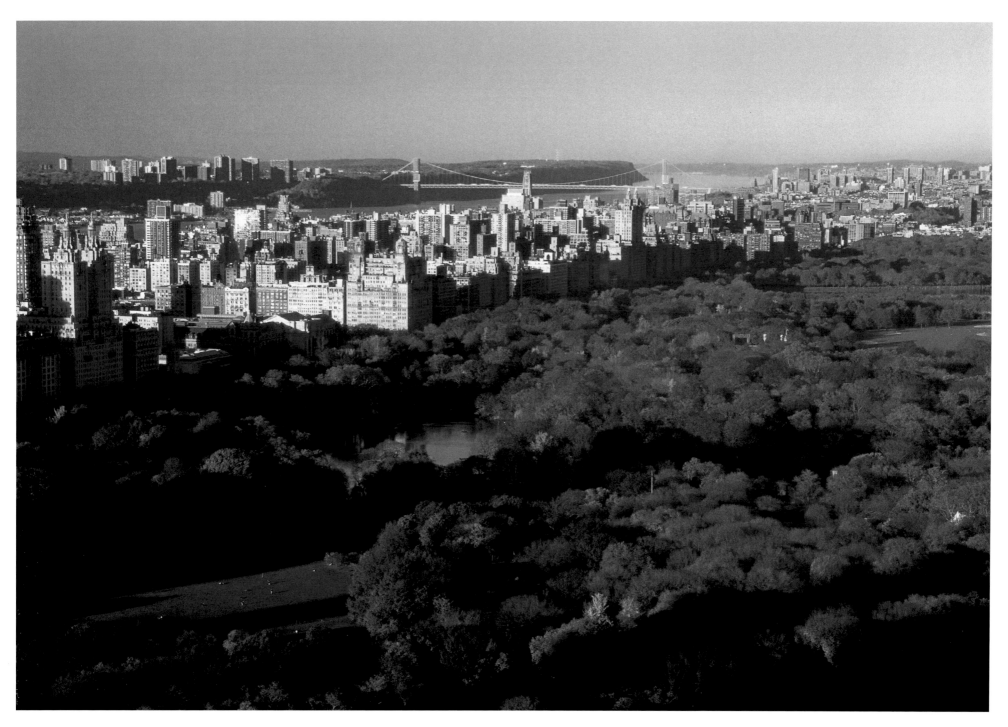

View northwest from an office on West 57th Street near Fifth Avenue.

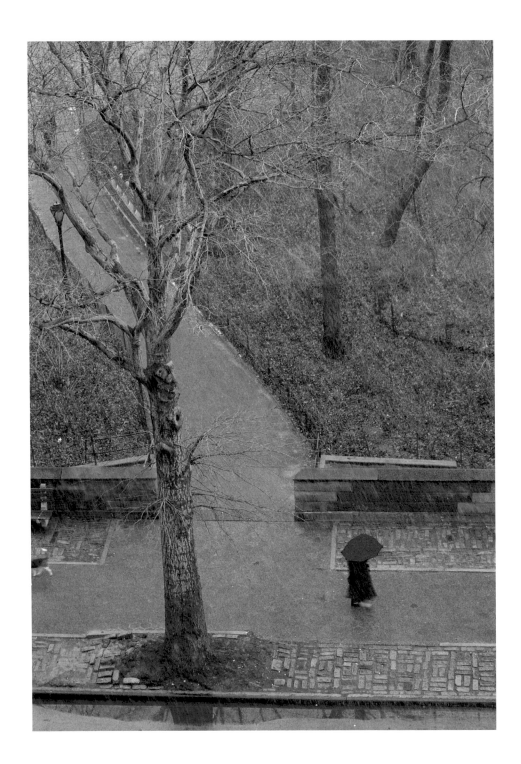

View across Central Park West from a 4th-floor window.

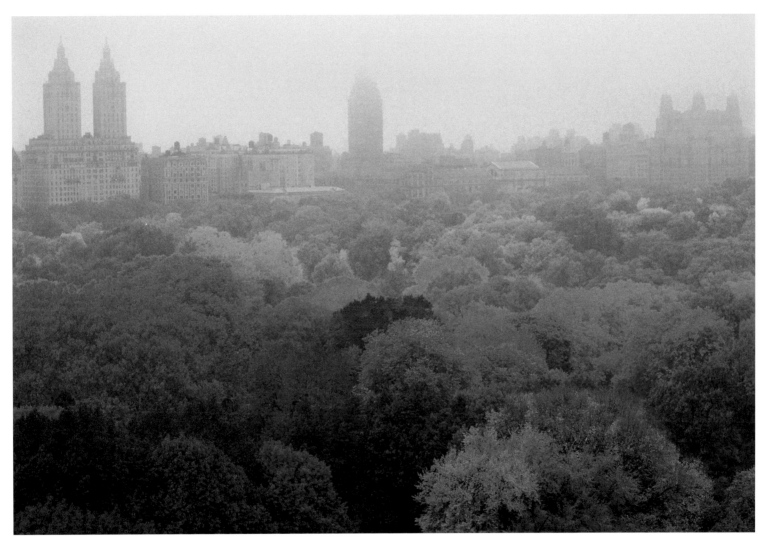

The Park shrouded in fog, looking west from Fifth Avenue in the upper 60s.

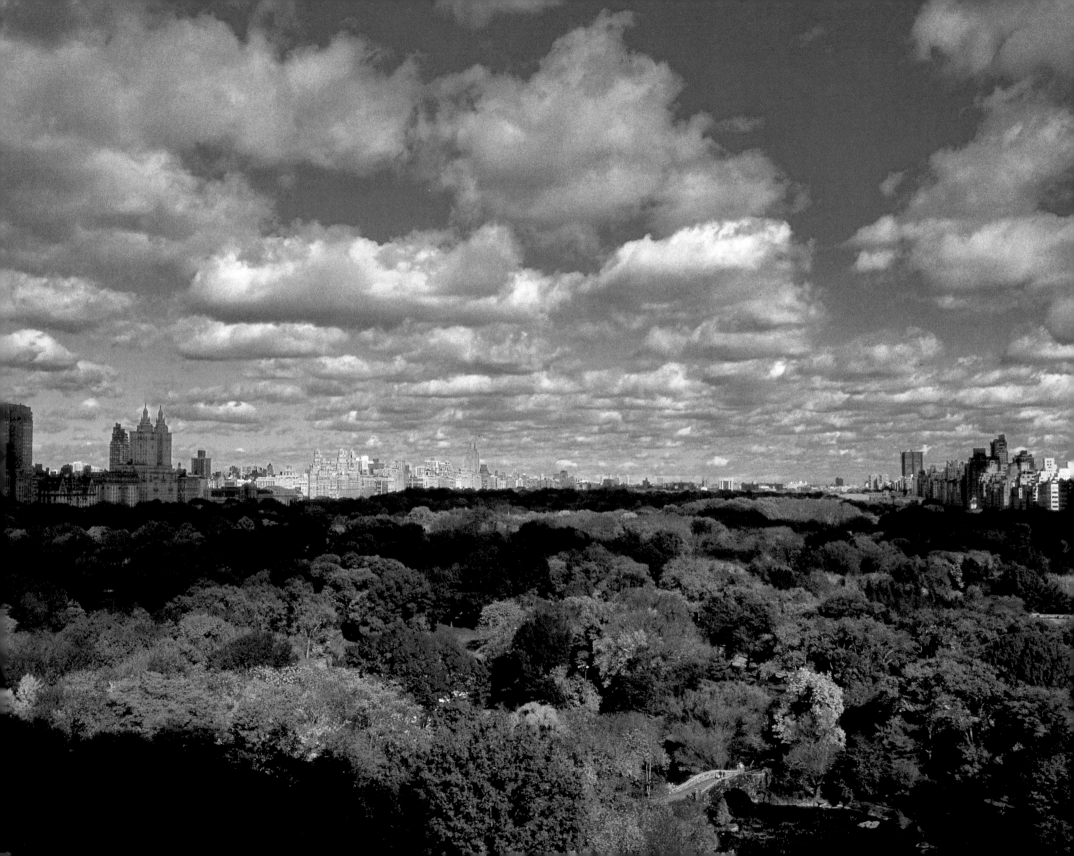

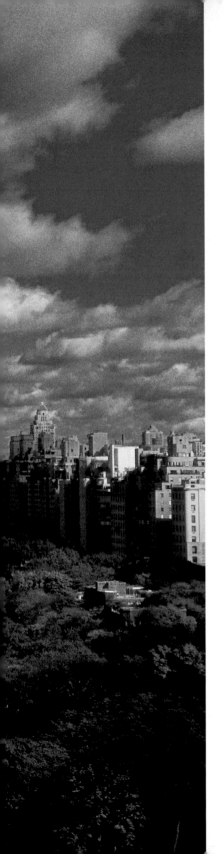

Landscape, viewed from 30 Central Park South.

"*What strikes me every time I look out over Central Park is an unexpected and immensely potent impression of untamed nature existing in the heart of the big city, revealing the possibility for a positive and heart-warming reconciliation between culture and wildlife, civilization and the natural environment.*"

GIORGIO ARMANI
Fashion Designer

WINTER

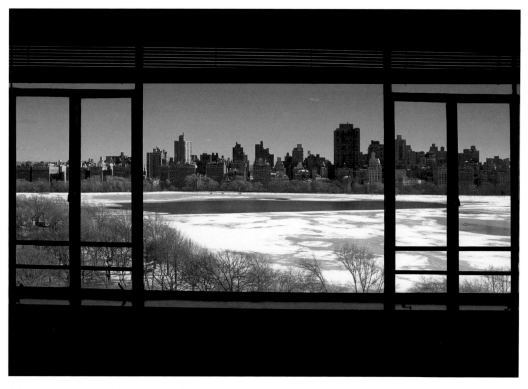

The Reservoir, viewed from a 17th-floor window on Central Park West at 92nd Street.

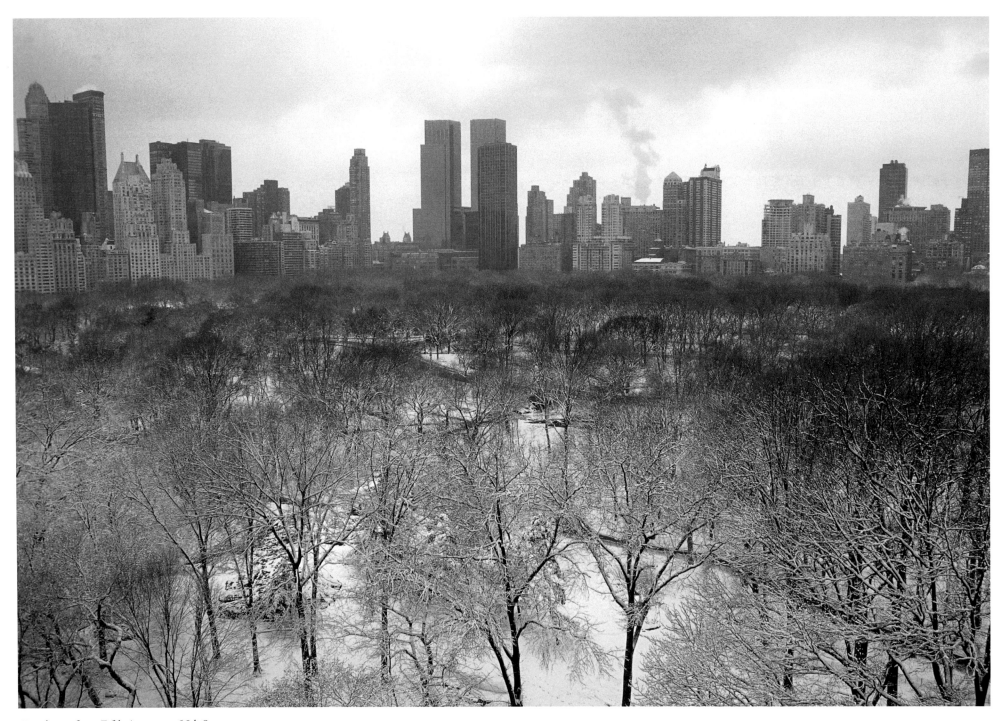

Landscape from Fifth Avenue at 66th Street.

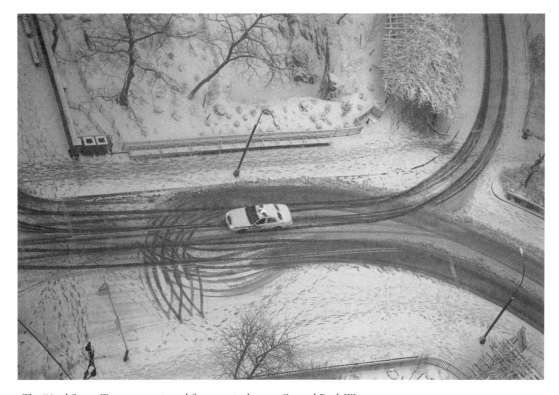

The 72nd Street Transverse, viewed from a window on Central Park West.

"*Intriguing landscapes have served as the backdrop for artists through the centuries, and Central Park is my sensational and wonderfully convenient landscape. Overlooking the Park from the eleventh floor where I set up an easel in my living room, I have painted portraits of friends as diverse as Rudolf Nureyev and Arnold Schwarzenegger. Different as they are as individuals, the one element that links the two paintings is my astonishing view of Central Park. In one, the background is the bare trees against the snow; in the other, the Park green with summer leaves.*"

JAMIE WYETH
Artist

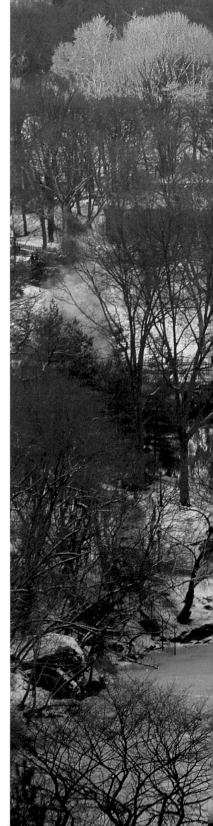

View with Bow Bridge from an office at 745 Fifth Avenue in the southwest corner of Central Park.

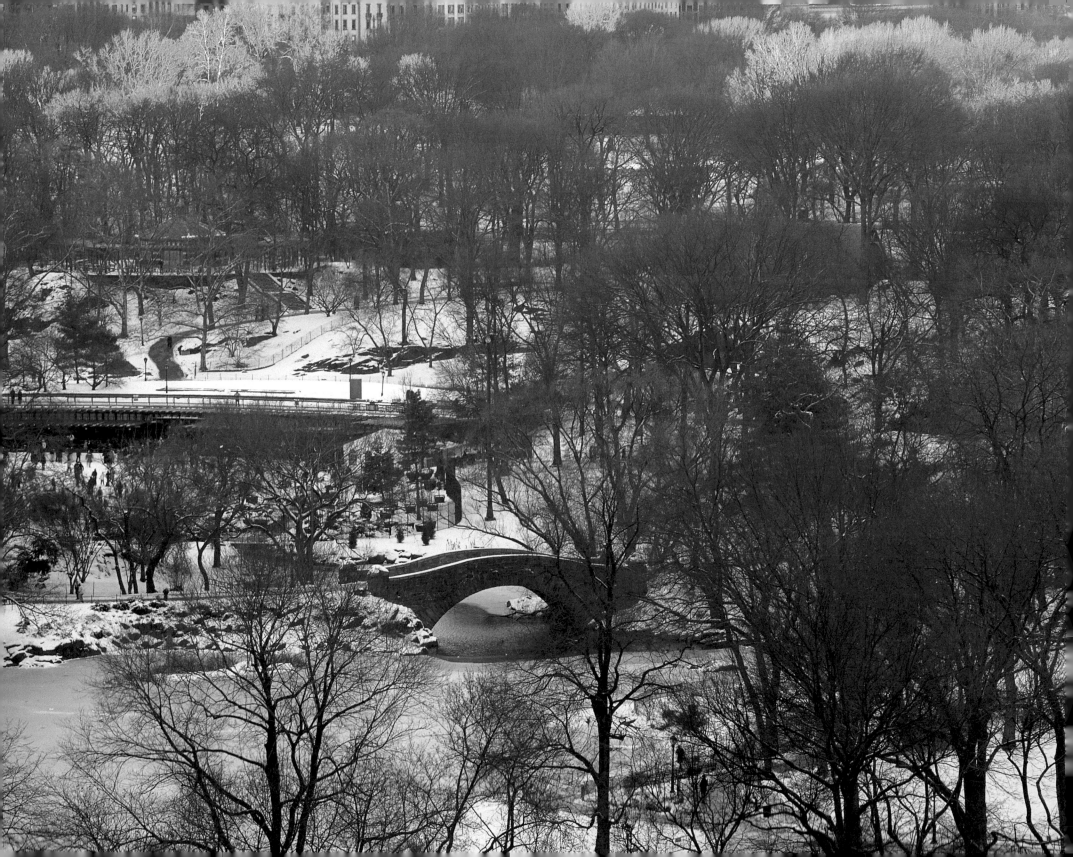

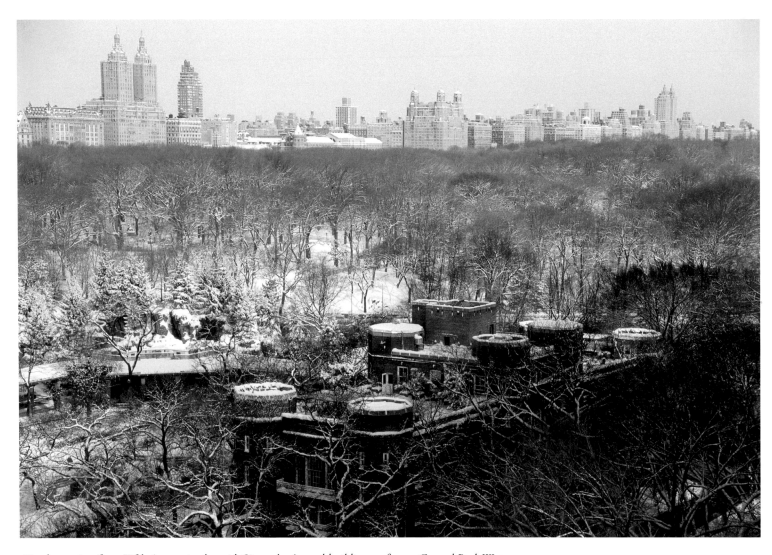

Northeast view from Fifth Avenue in the mid-60s to the Arsenal building rooftop to Central Park West.

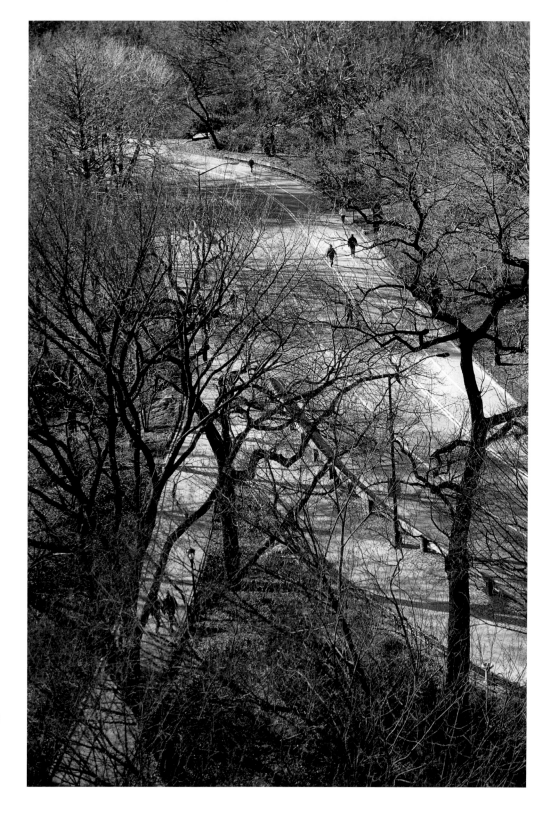

The 85th Street Transverse, seen from Fifth Avenue.

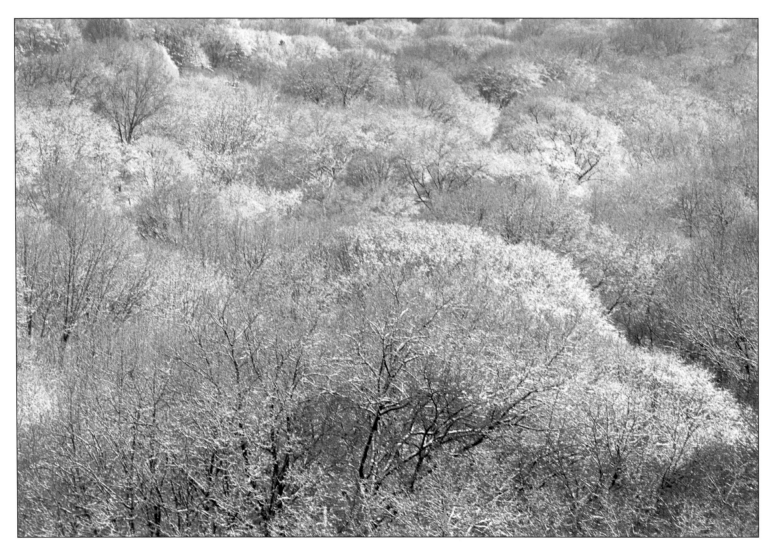

Ice-laden trees, viewed from Fifth Avenue in the mid-60s (above and opposite).

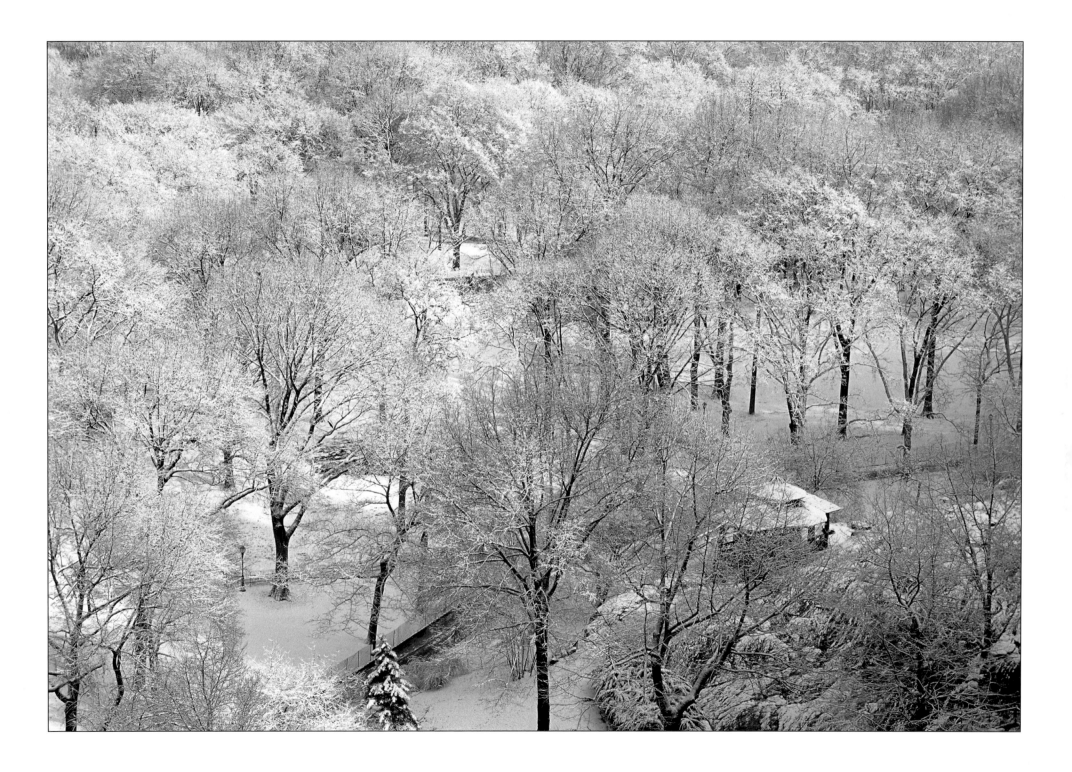

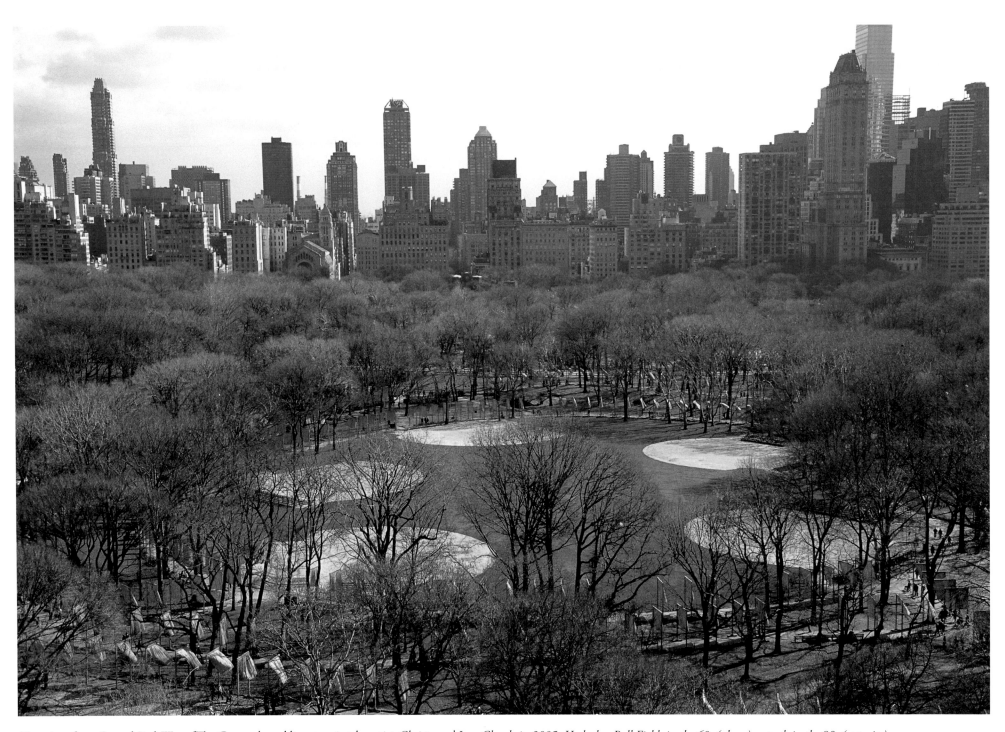

Two views from Central Park West of The Gates, *the public art project by artists Christo and Jean Claude in 2005: Heckscher Ball Fields in the 60s (above); a path in the 90s (opposite).*

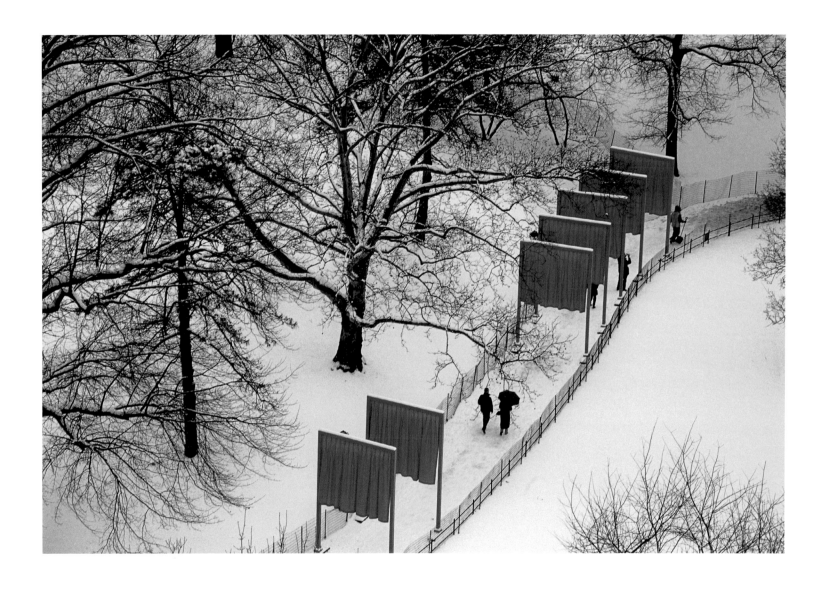

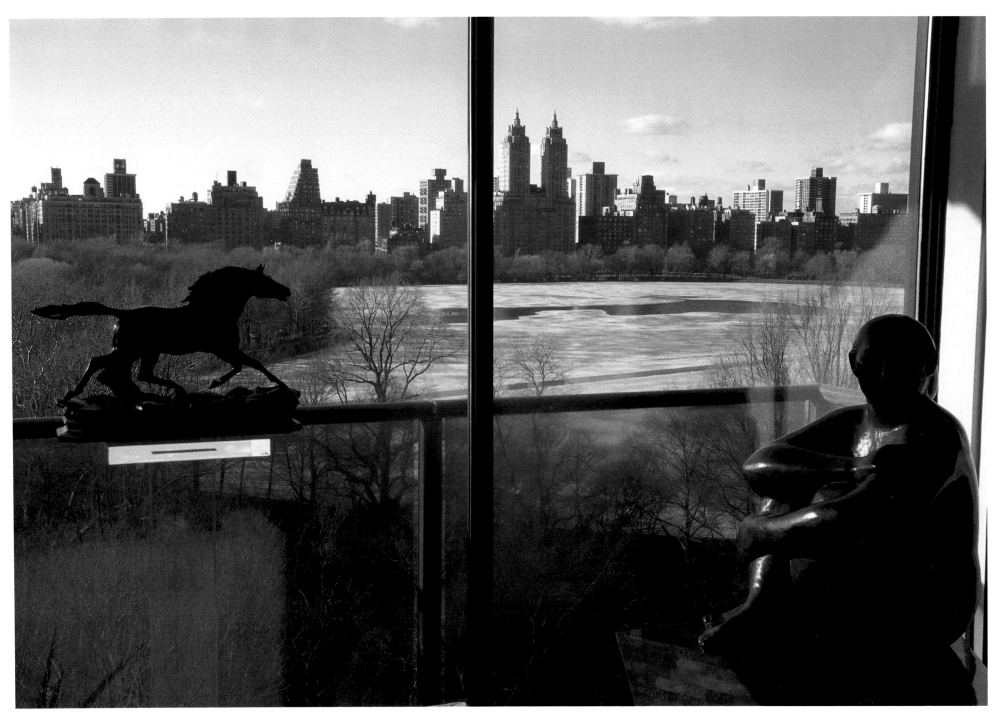

The Reservoir, viewed from Fifth Avenue in the 80s.

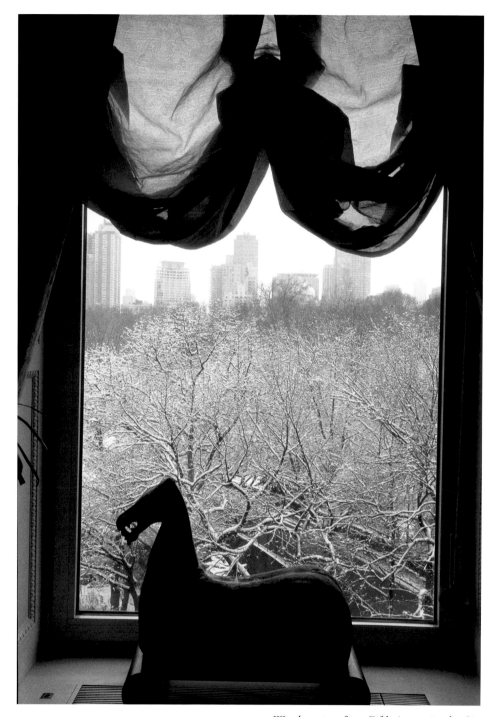

Window view from Fifth Avenue in the 60s.

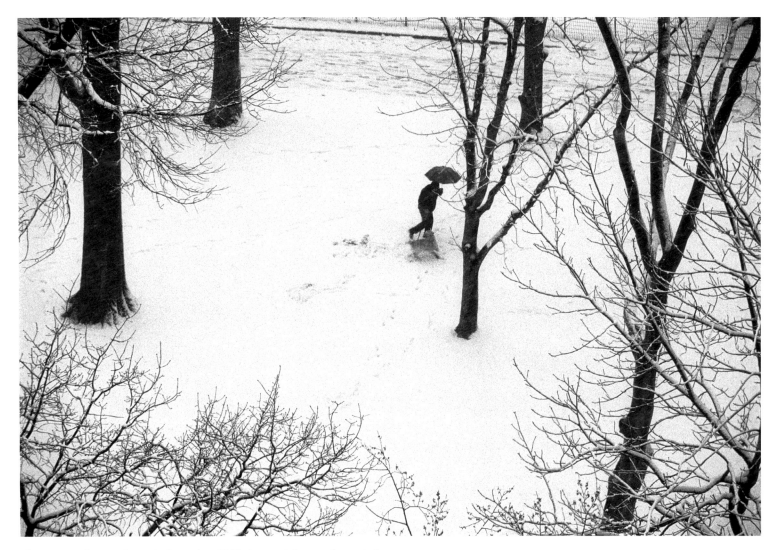

Snow views from various windows along Fifth Avenue (above and opposite).

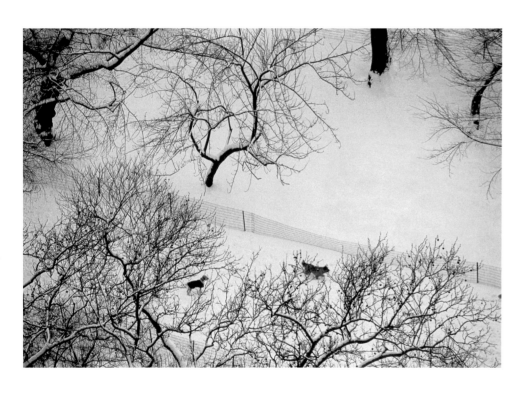
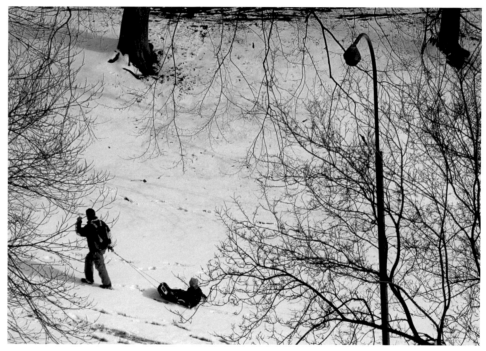

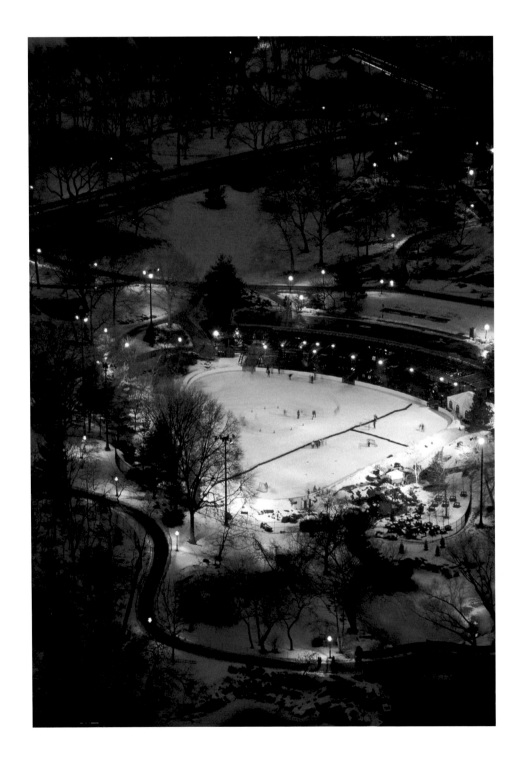

The Wollman Skating Rink, seen from an upper window of the General Motors building at 59th Street and Fifth Avenue.

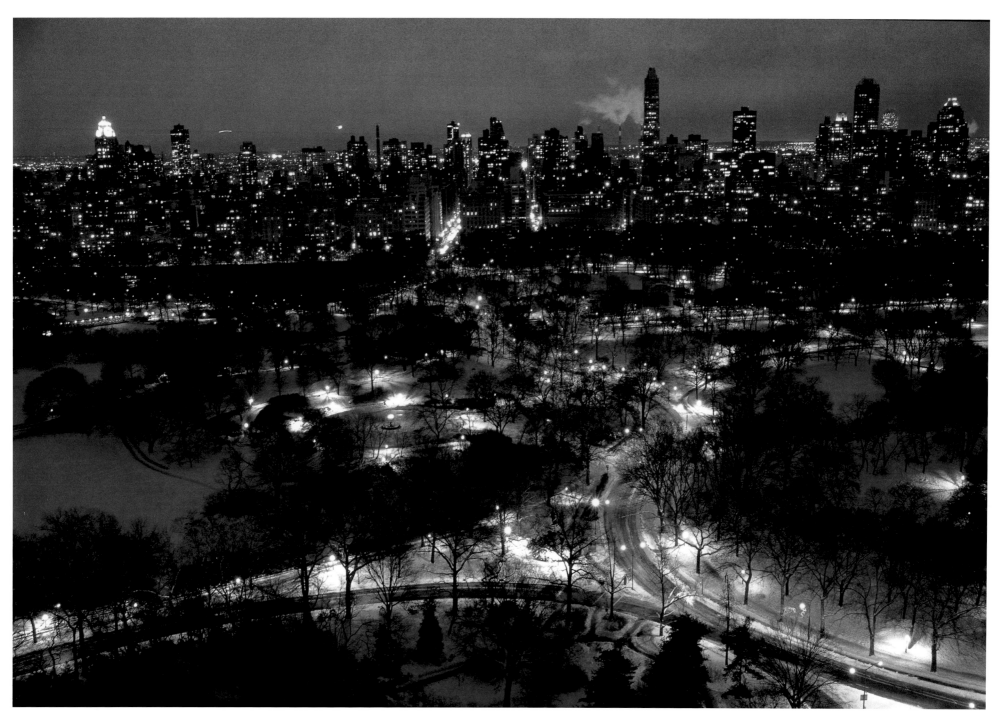

The 72nd Street Transverse, viewed from the Majestic apartment building.

"I'm a New Yorker—born here. Now I live in a seventeenth-floor apartment. From several windows Central Park resembles an undulating, ever-changing sea of color.

Sometimes I sit at my desk and daydream about when my three children were young, and I can hear them laughing as they sail their tiny boats, ride the carousel, scramble over the Alice in Wonderland sculpture, glide across the ice. Now in my mind's eye, all the years flow together. My daydream drifts to the clock at the children's zoo as it strikes the hour and a fantasy bronze animal orchestra prances round and round. The hour has struck, and I turn away and once again begin scribbling on my pad."

BARBARA GOLDSMITH
Writer and Historian

View of the Harlem Meer from Bianca's on the Park at 110th Street and Malcolm X Boulevard.

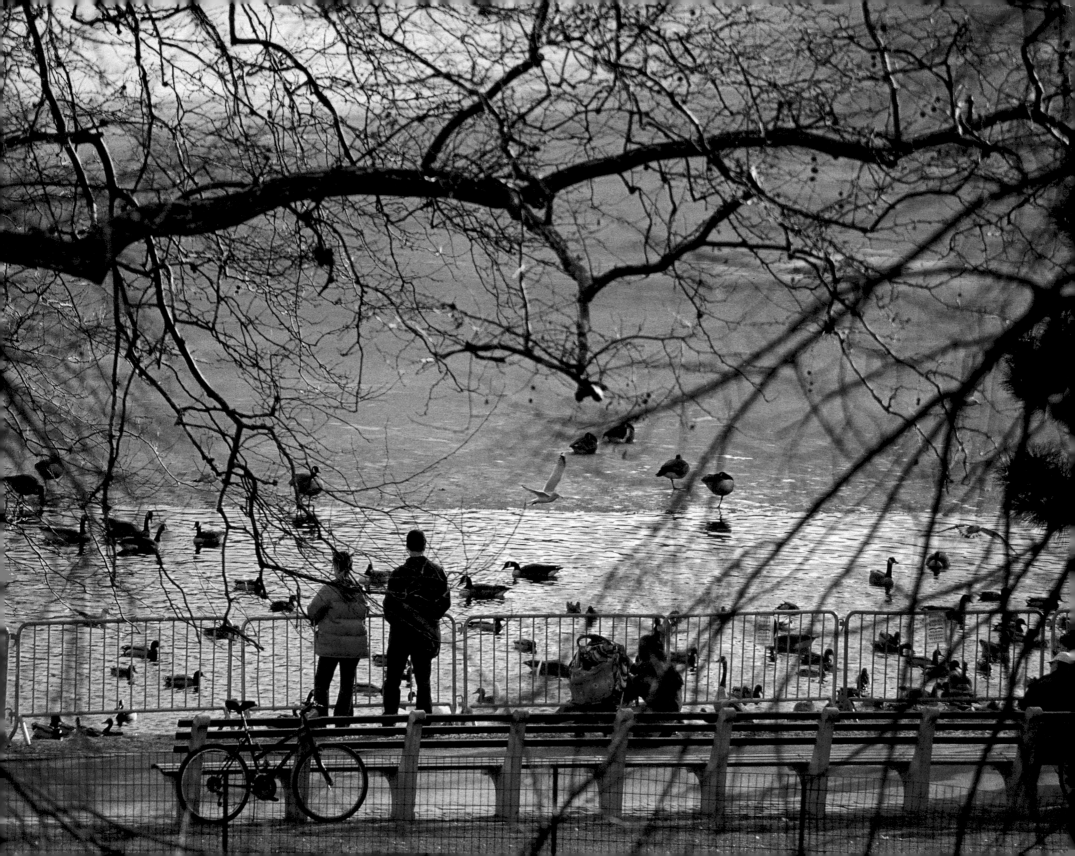

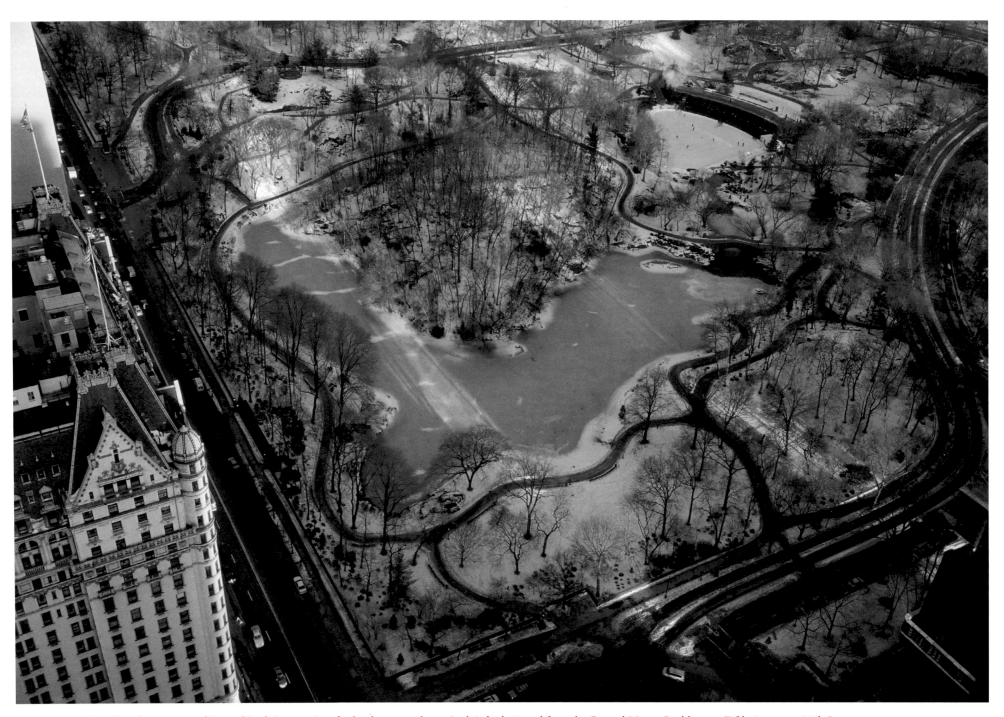

The Plaza Hotel and southeast corner of Central Park (opposite) and a landscape northwest (right), both viewed from the General Motors Building on Fifth Avenue at 59th Street.

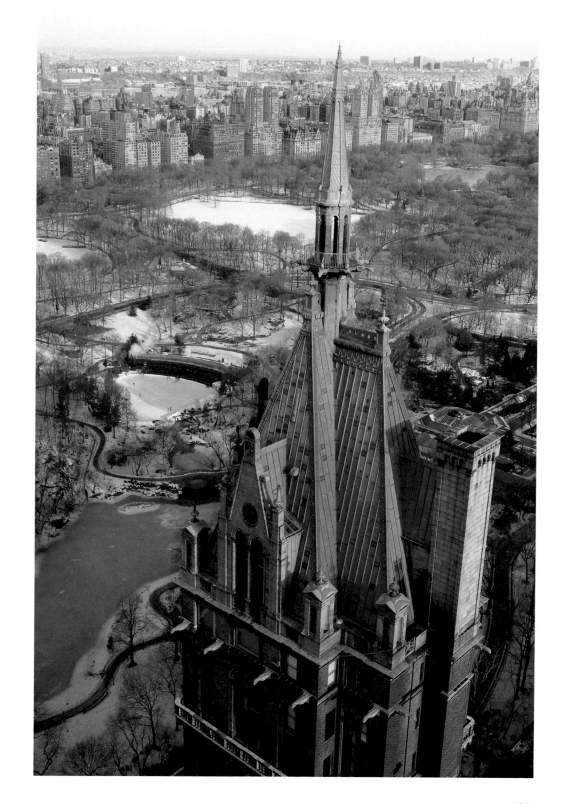

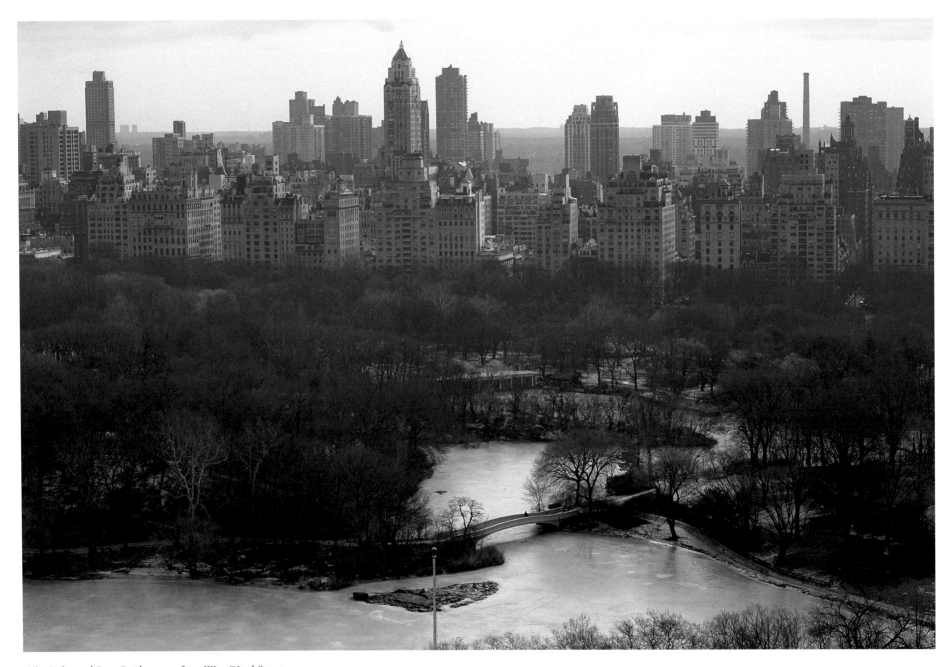

The Lake and Bow Bridge, seen from West 72nd Street.

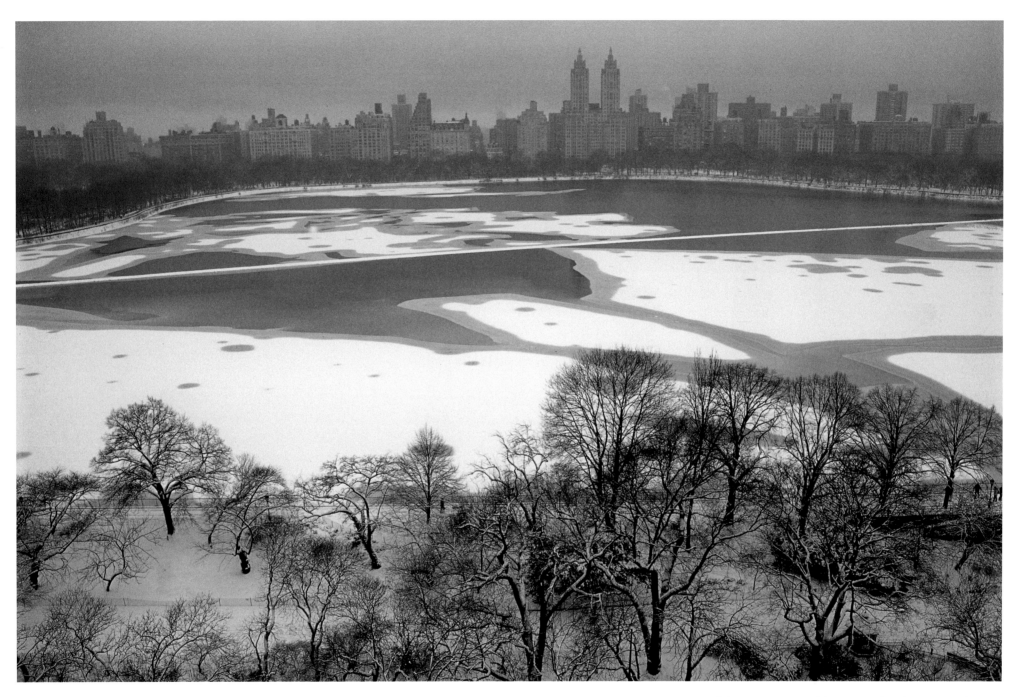

The Reservoir, viewed from Central Park West at 90th Street.

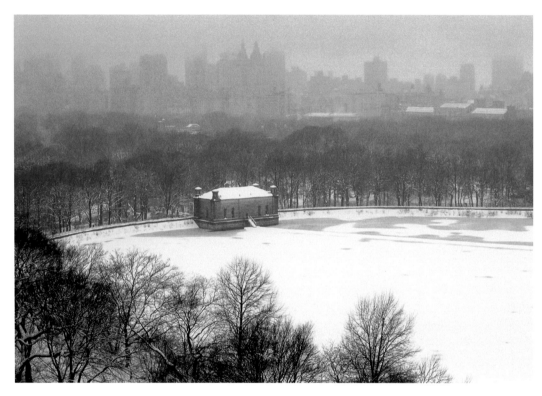

Views of the Reservoir from upper Fifth Avenue (above and opposite).

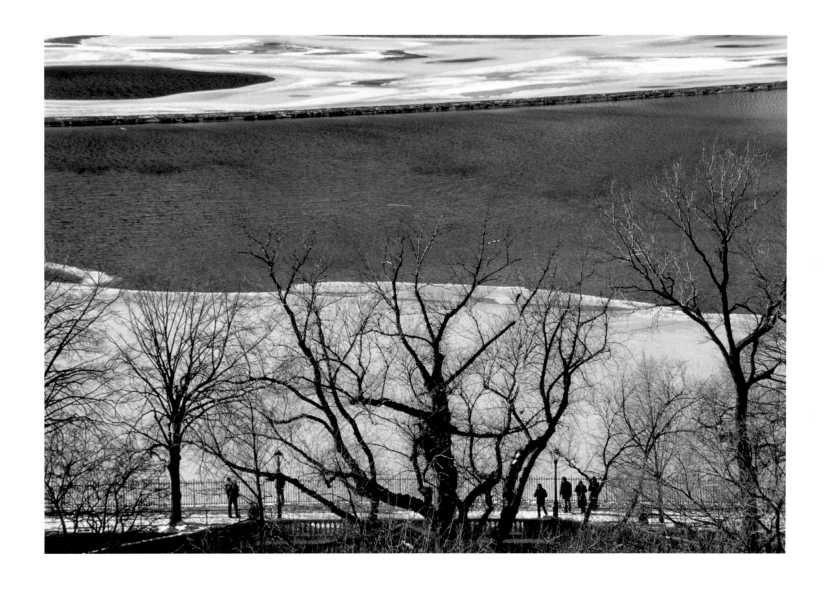

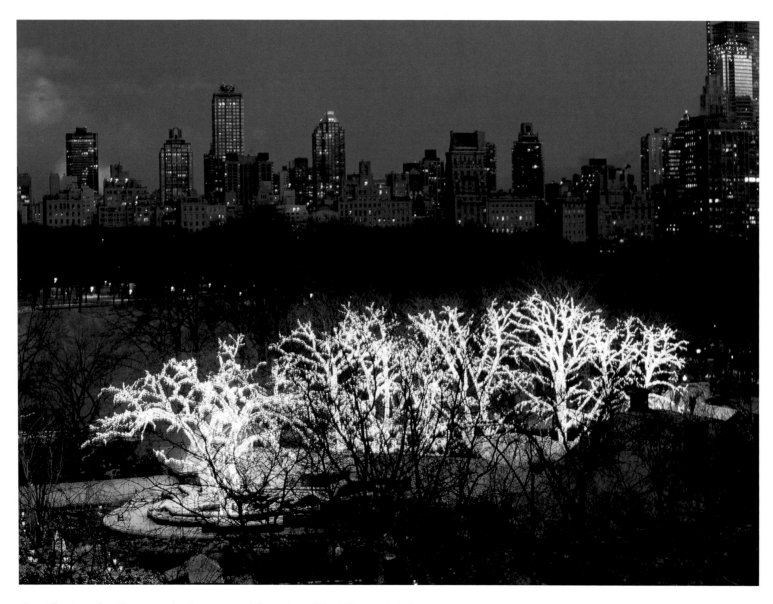

Trees illuminated at Tavern on the Green, viewed from Central Park West at 67th Street.

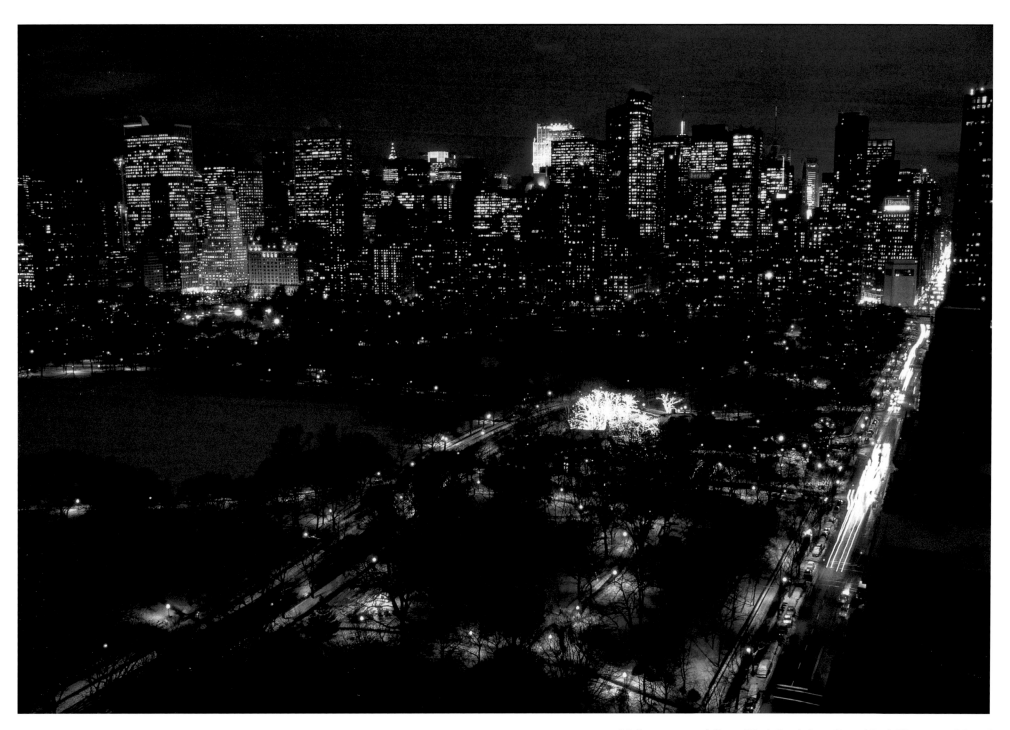

Night view toward Central Park South from Central Park West at 72nd Street.

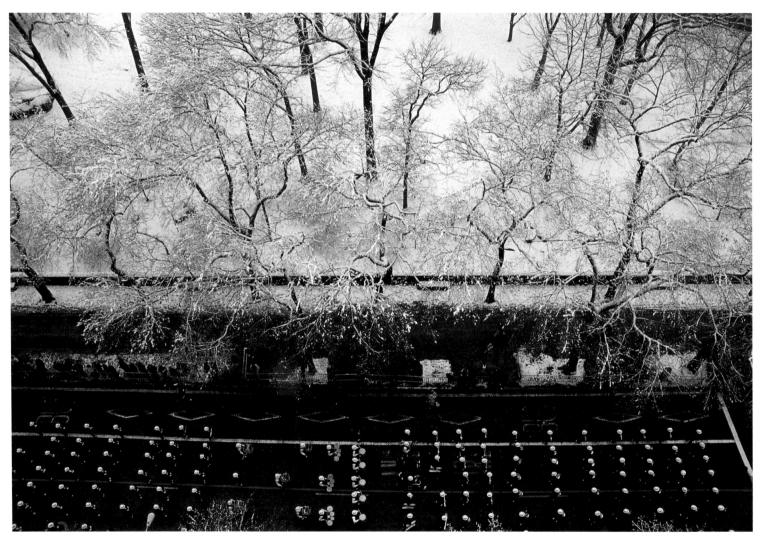

A St. Patrick's Day Parade on Fifth Avenue with ice-laden trees of Central Park behind, seen from a 14th-floor window in the East 60s.

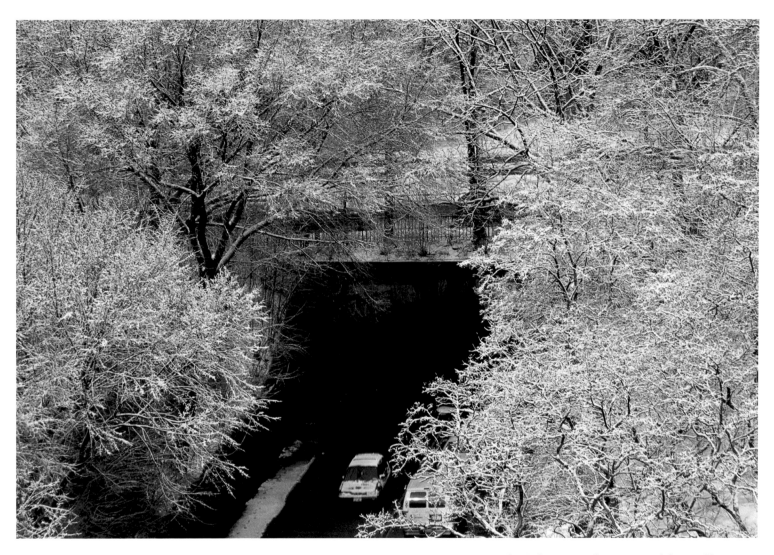

The 65th Street Underpass, viewed from Fifth Avenue.

"While the risk I encounter daily could certainly kill me, the thrill it provides makes up for the fact that I am, ultimately, just cleaning a window. It's different from a good view balancing out a long job. Because even though the spectacular sight of the Central Park Reservoir from a 21st-story apartment in the Eldorado at Central Park West and 90th Street does ease the drudgery of cleaning that building's cut-up casements—24 panes of glass per window— such a view is really just a magnificent distraction."

IVOR HANSON
Writer and former window-washer

from "The Allure of the Ledge," *New York Times*,
January 23, 2000

The Reservoir, viewed from Central Park West at 90th Street.

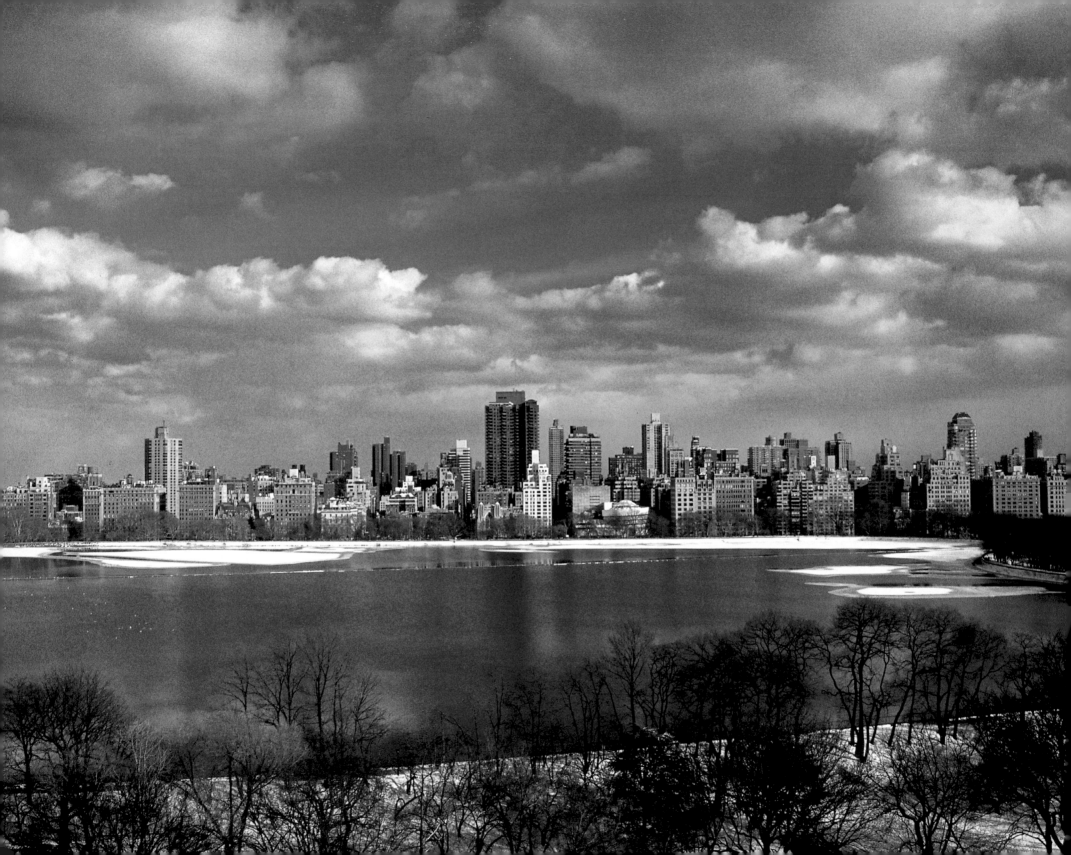

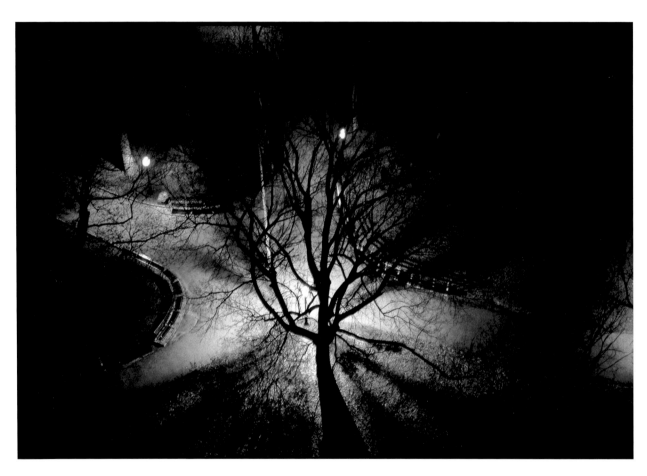

A Central Park luminary, viewed from a 21st-floor penthouse on Fifth Avenue.

Early morning view across Central Park West from a 4th-floor window on 70th Street.

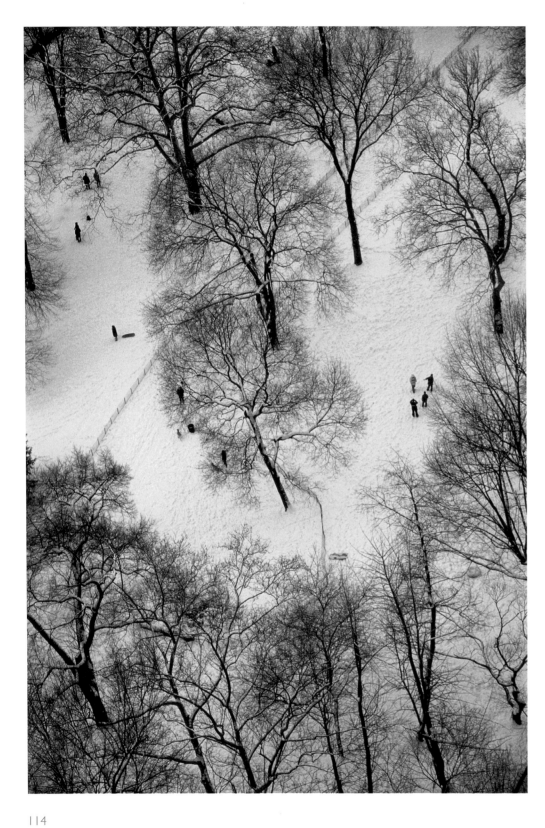

Winter views from the Majestic apartment building on Central Park West (left and opposite).

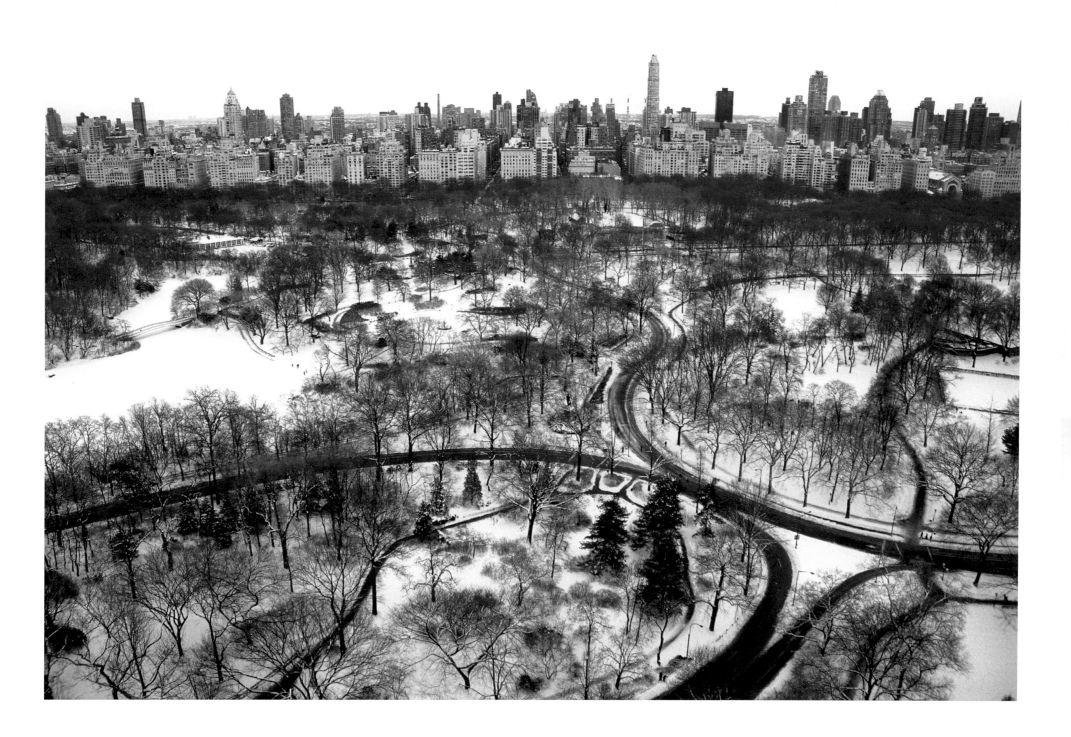

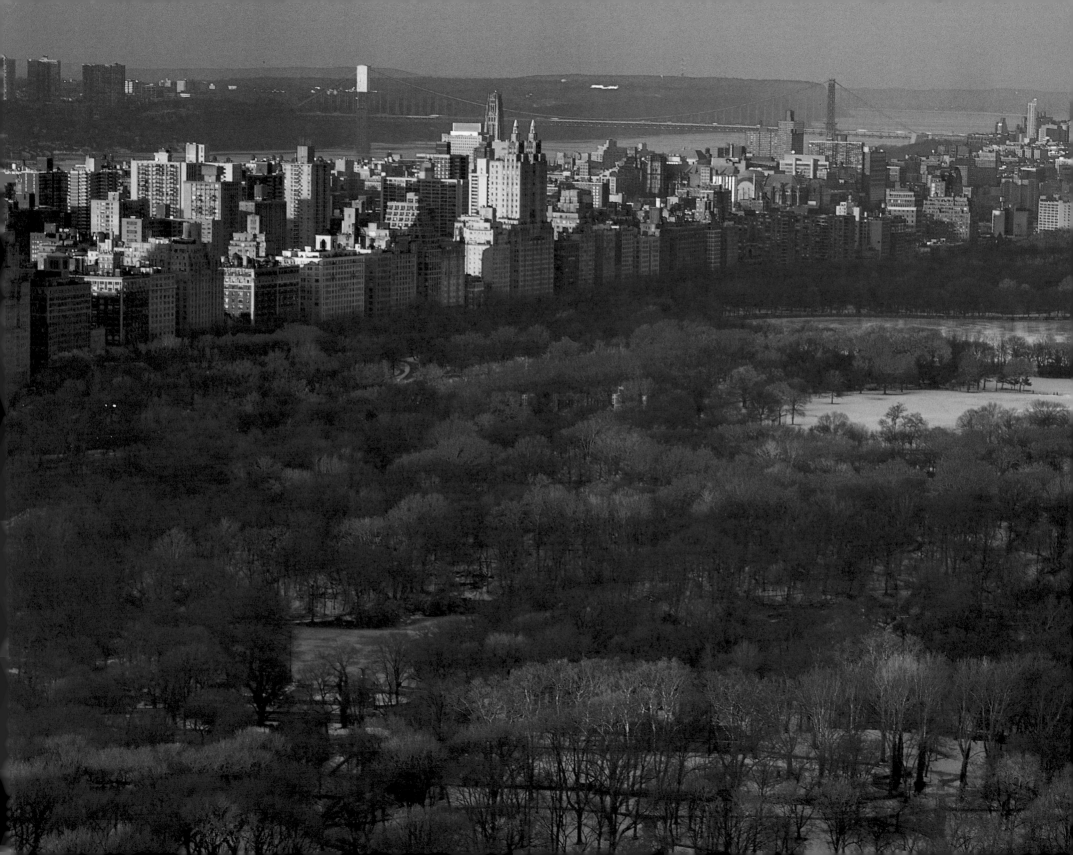

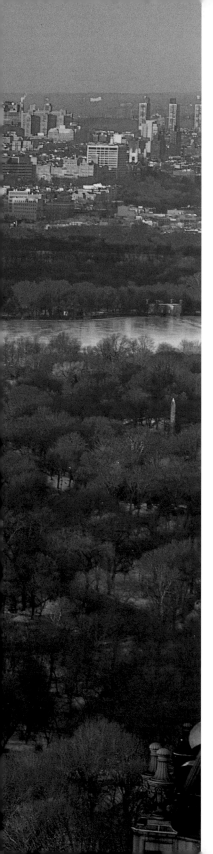

"I can see Central Park from my apartment and my office. It never fails to move me—every season is vibrantly different; every day is unique. To me, Central Park is as integral to New York City as the Statue of Liberty. It's the very beautiful core of the greatest city on earth."

DONALD J. TRUMP
Chairman and CEO
The Trump Organization

View northwest at dusk from Fifth Avenue at 60th Street.

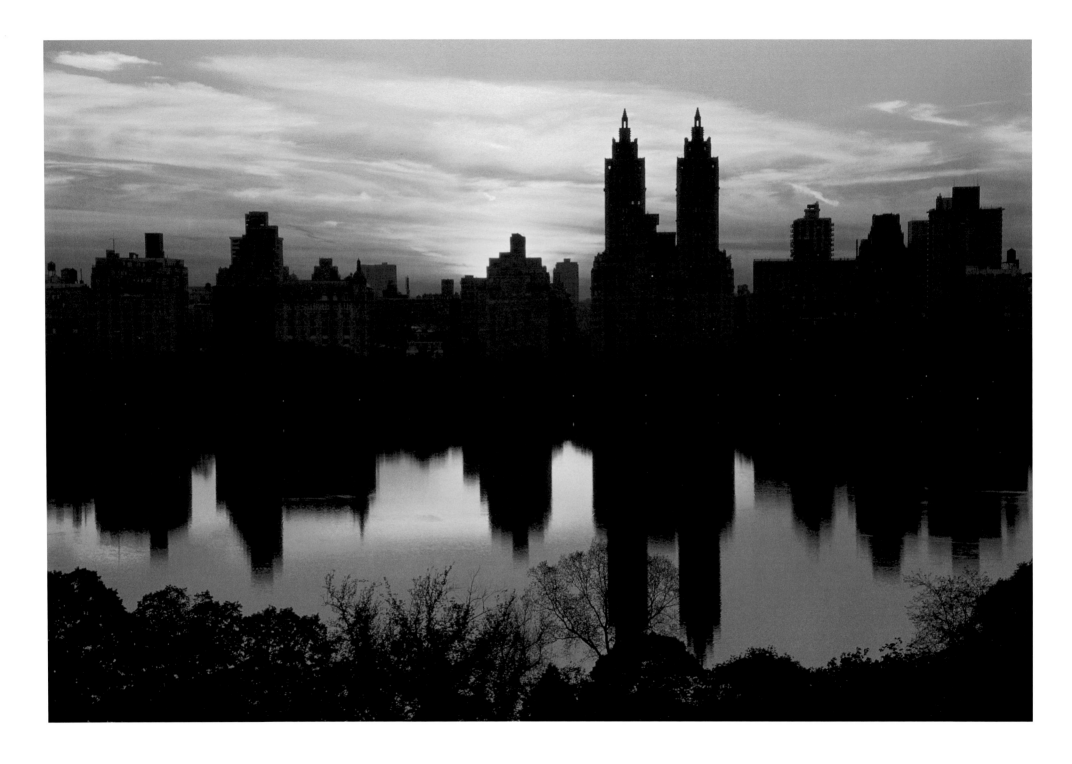

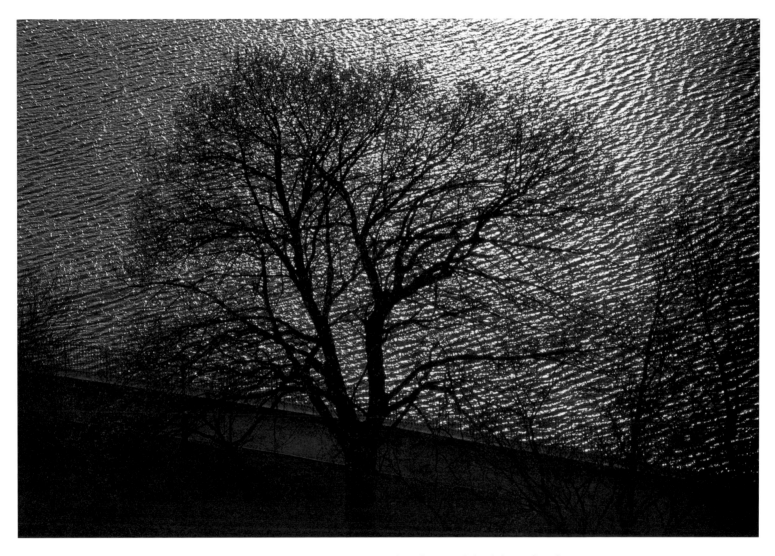

Sunset views of the Reservoir from Fifth Avenue in the 90s, with an American elm (above) and the skyline reflected (opposite).

SPRING

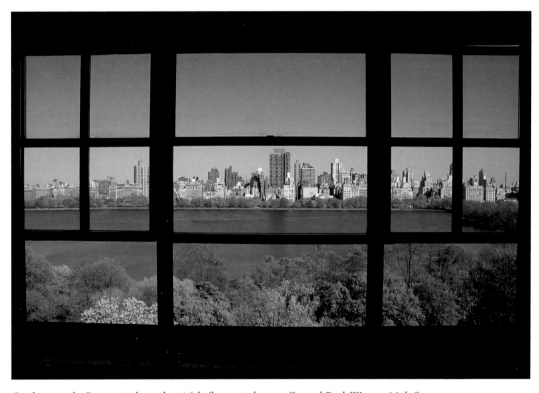

Looking to the Reservoir through a 14th-floor window on Central Park West at 89th Street.

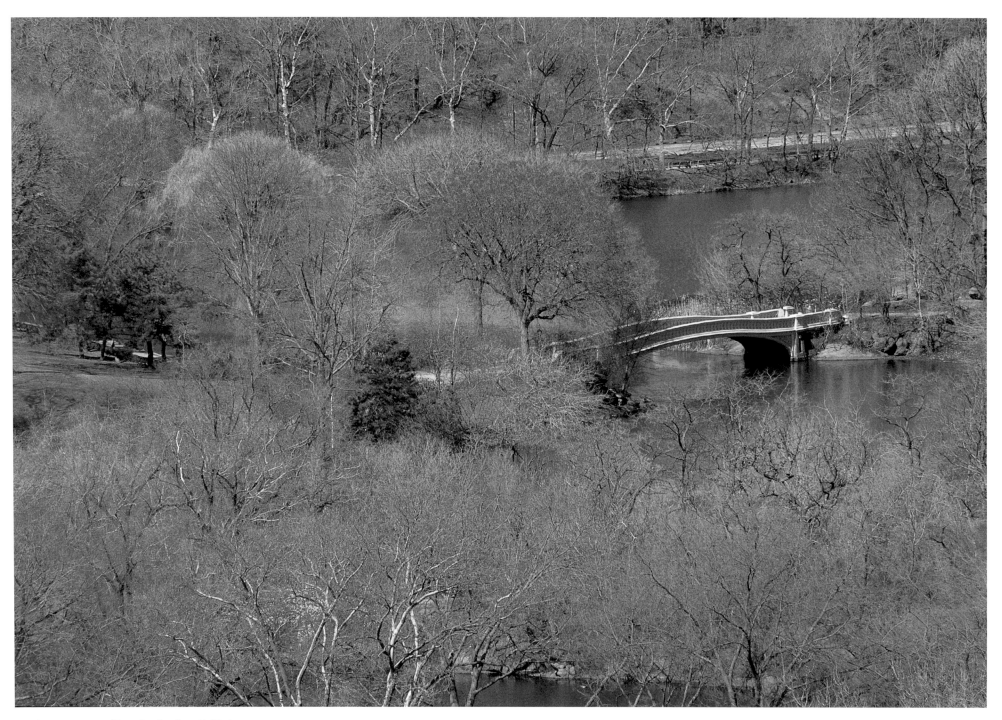

Early spring view of Bow Bridge from Fifth Avenue.

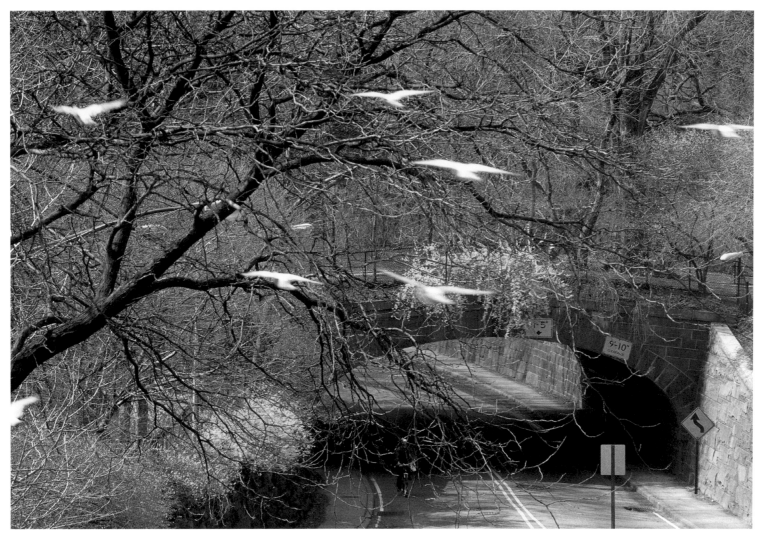

The 79th Street Underpass, viewed from Fifth Avenue.

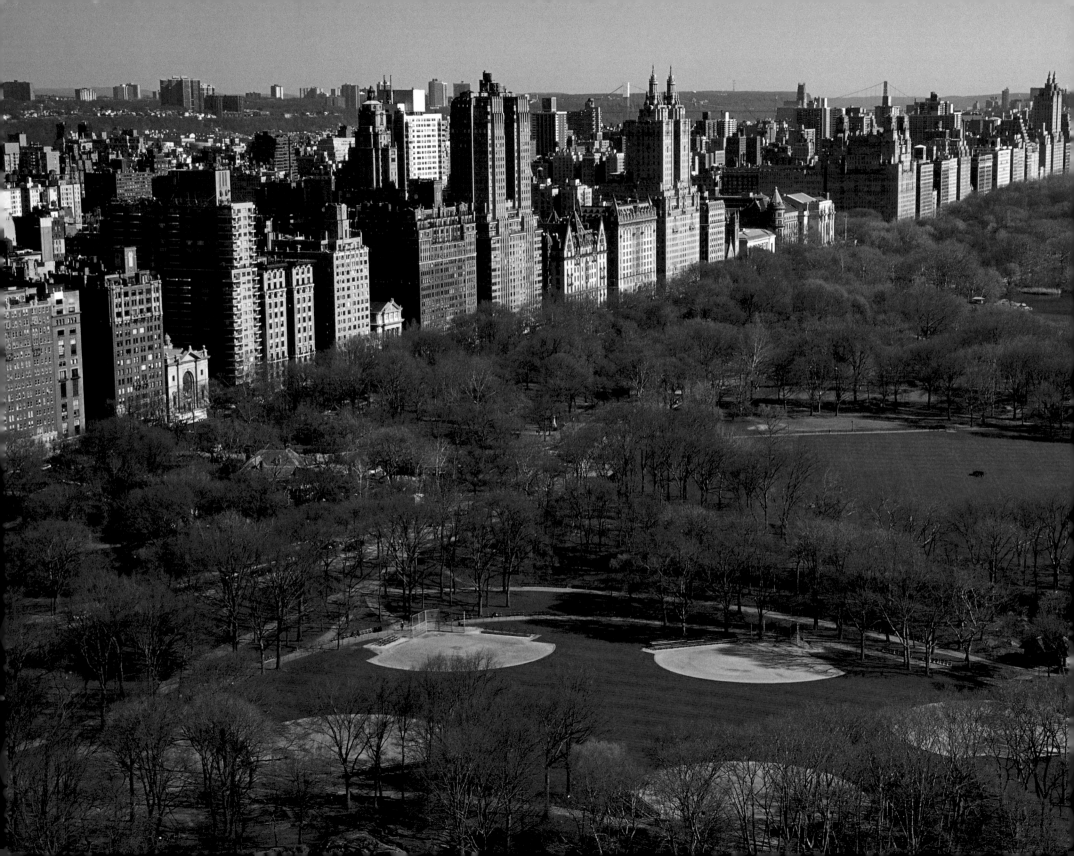

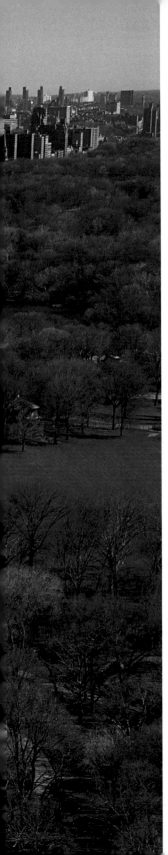

"*My windows face the park. It's just good I don't have to mow the lawn.*"

ELLIOTT ERWITT
Documentary and Advertising Photographer

Landscape north, viewed from the New York Athletic Club on Central Park South near Seventh Avenue.

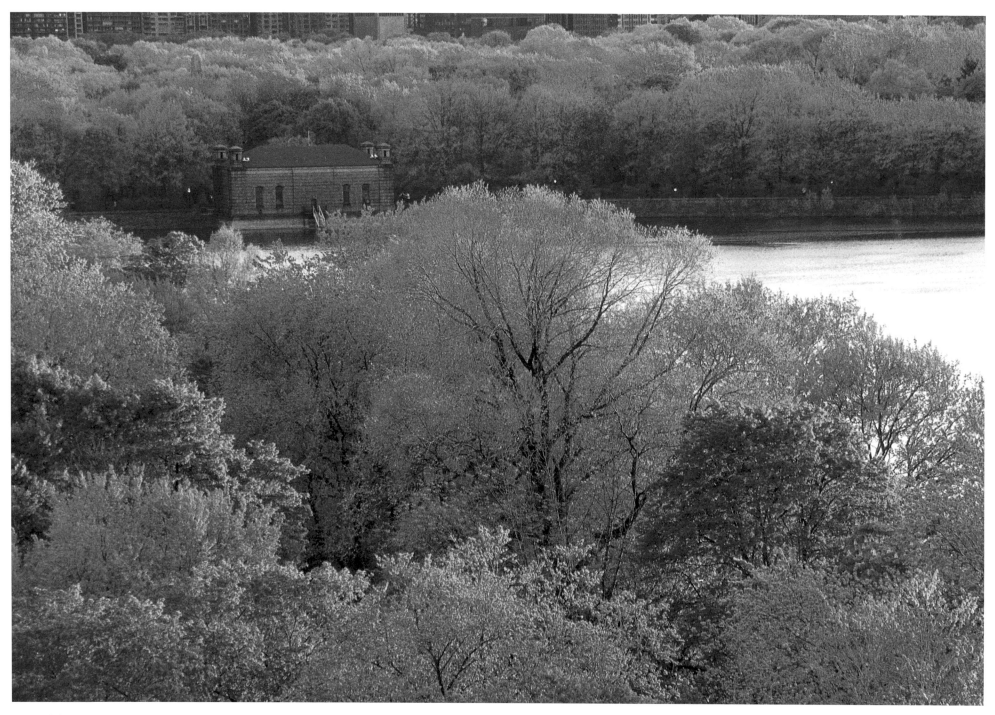

View of the Reservoir with the South Gate House from Fifth Avenue at 69th Street.

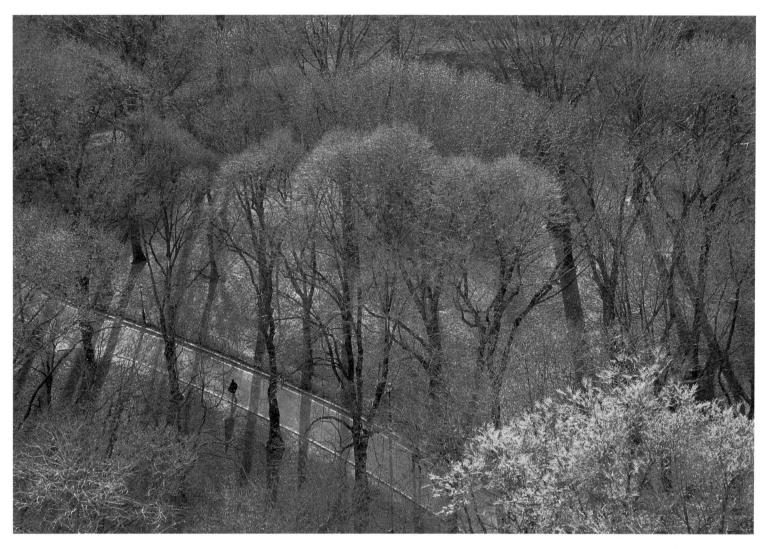

Pedestrian, seen from Fifth Avenue through budding leaves.

A European hornbeam near Conservatory Water, seen from a 19th-floor window in the mid-70s.

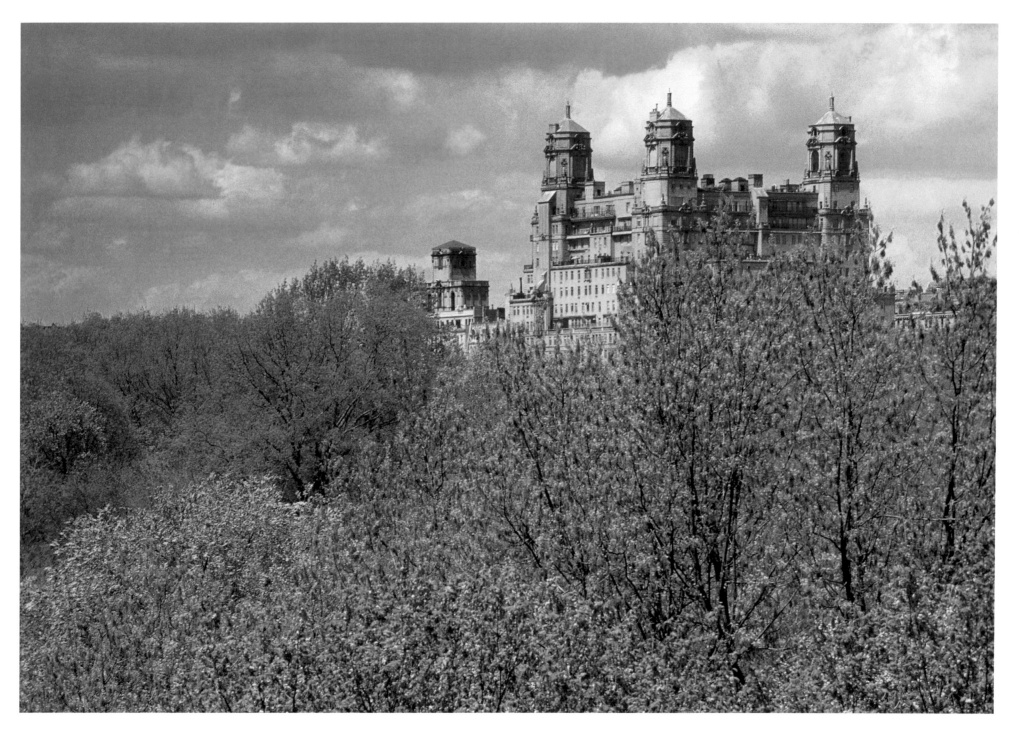

The Beresford apartment building looms beyond Central Park trees, seen from Fifth Avenue in the low 70s.

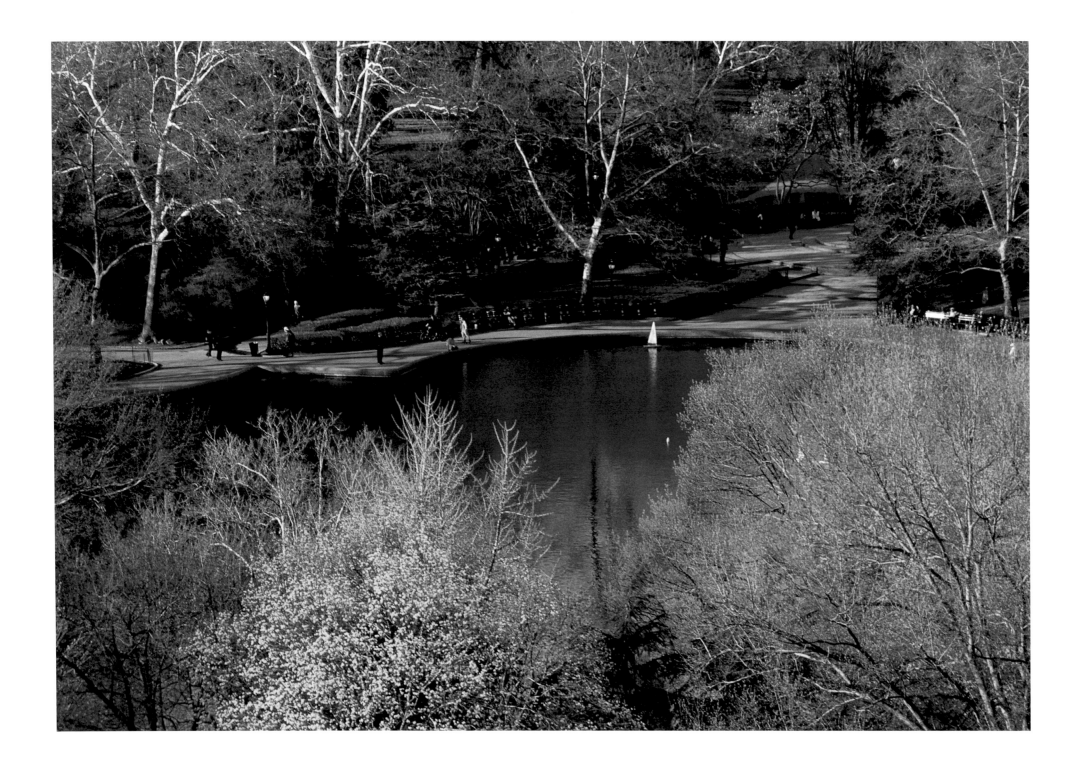

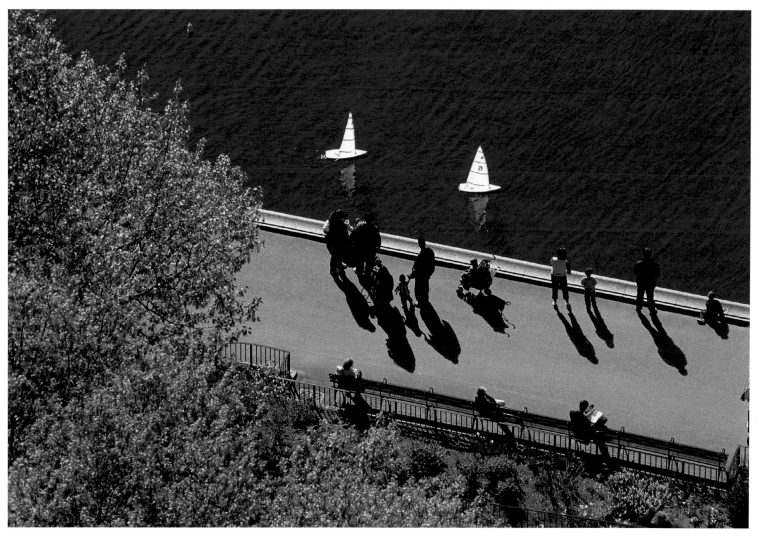

Two views of Conservatory Water, commonly known as the Model Boat Pond, from Fifth Avenue at 69th Street (opposite) and from 74th Street (above).

Glimpses of pedestrians from Fifth Avenue (left) and Central Park West (opposite).

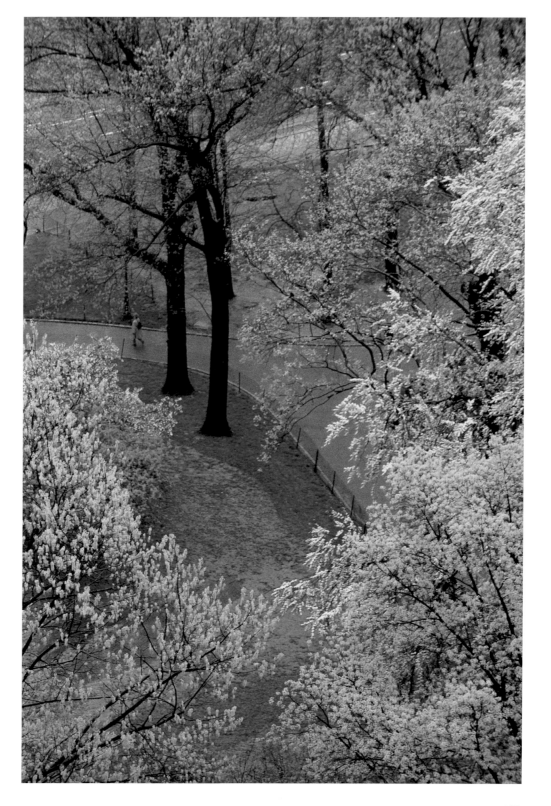

"*Trees and children. Trees and their changing colors. Wonder and magic. Children and their playful laughter, accompanied by concerned nannies and grateful grandparents. Naturally, other image-hunting and joy-hungry people are also attracted by the Park. But the children alone represent its mystery.*"

ELIE WIESEL
Writer, Professor, and Nobel Peace Laureate

A glimpse of children on swings from a Fifth Avenue window.

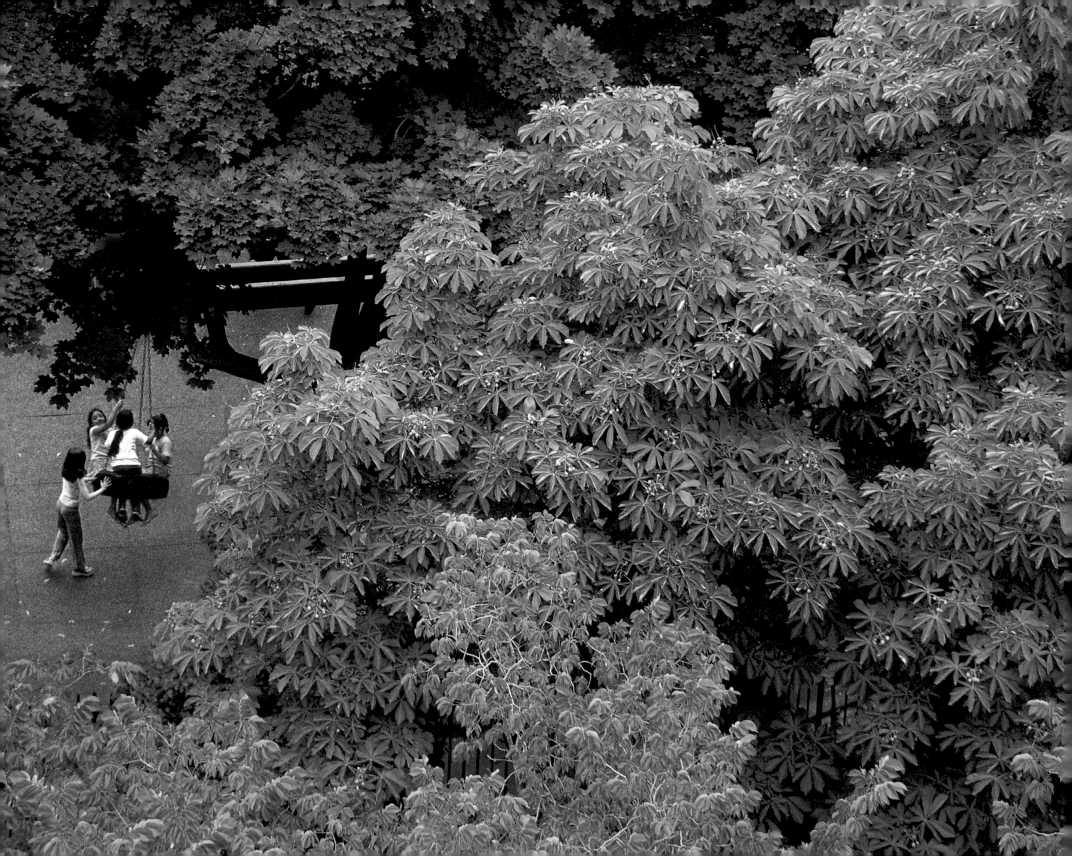

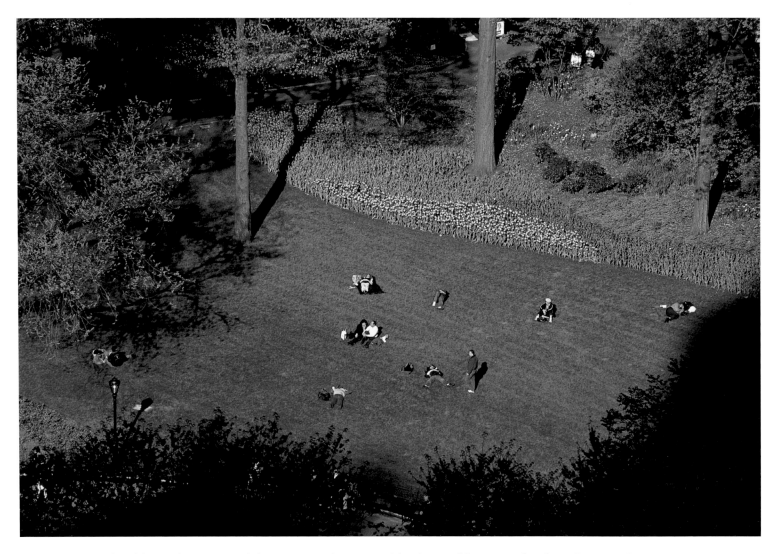

The southeastern edge of the Pond (opposite) and the grassy area adjacent to it (above), viewed from Central Park South near Sixth Avenue.

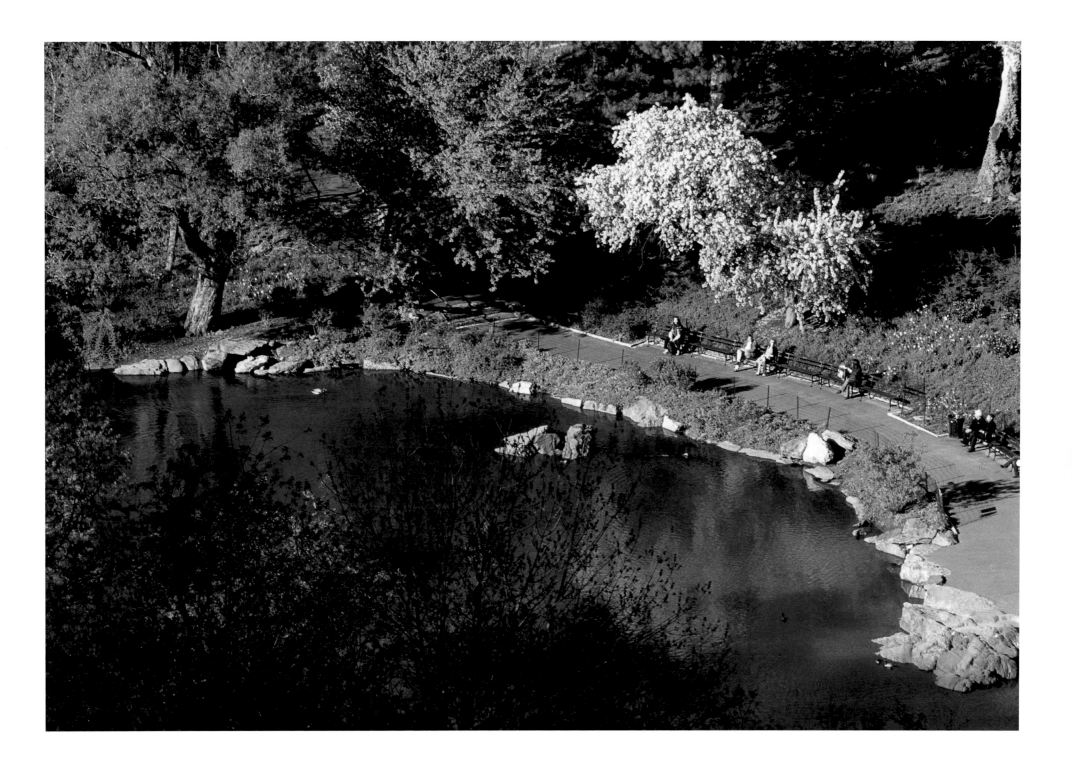

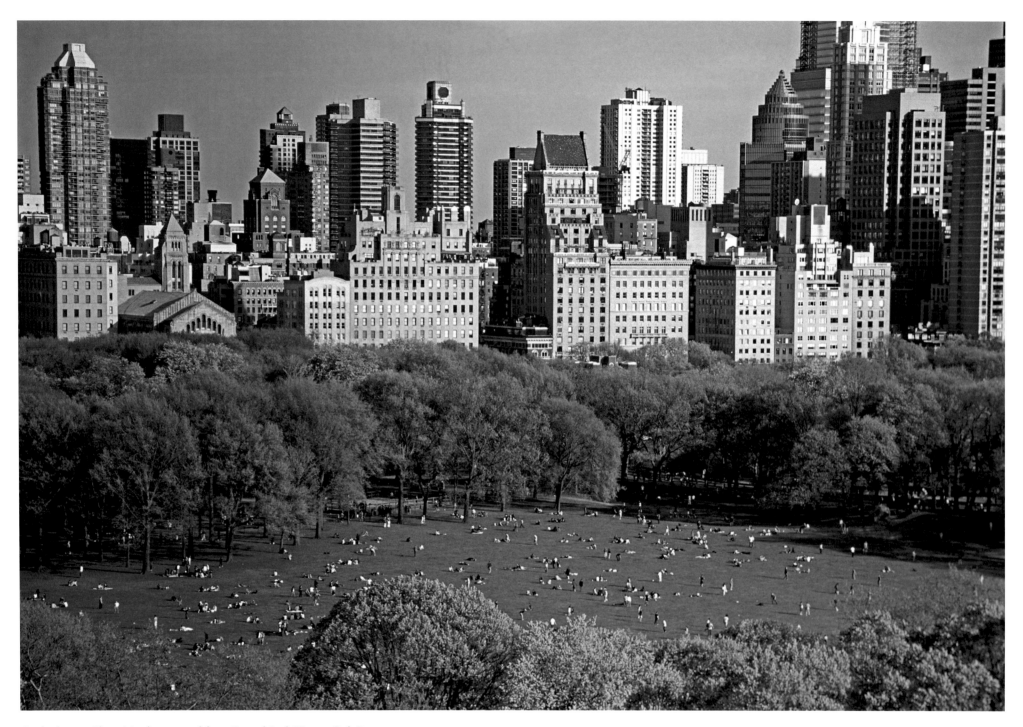

Sunbathers on Sheep Meadow, viewed from Central Park West at 69th Street.

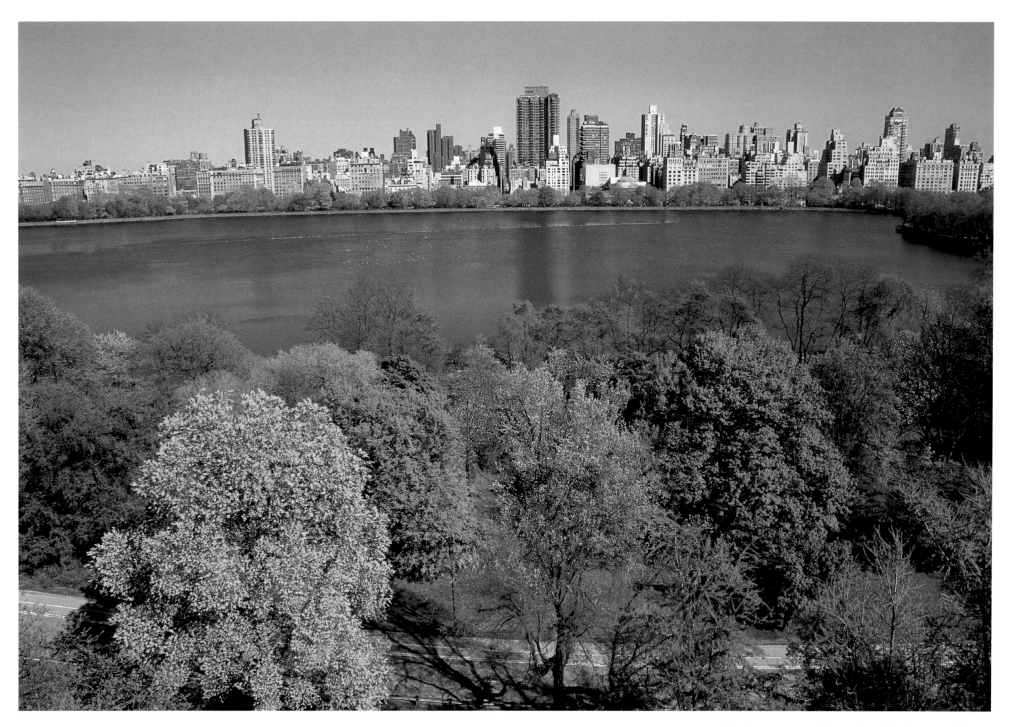

The Reservoir, viewed from Central Park West in the 90s.

Conservatory Garden at 105th Street, viewed from the Terence Cardinal Cooke Health Care Center on Fifth Avenue: children seated on a bench in the north garden (left); the fountain with double allée of white and pink crabapple trees in the central garden (opposite).

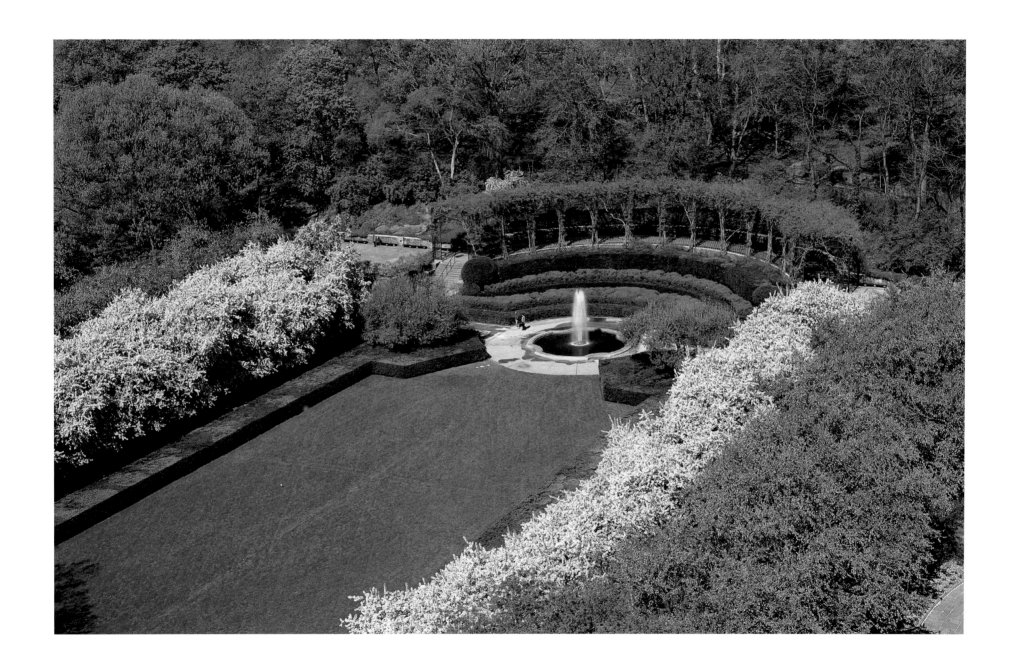

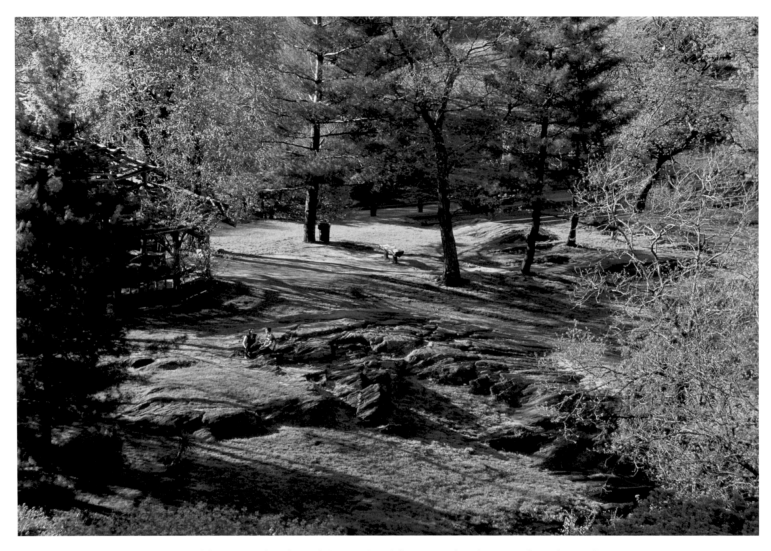

Manhattan schist outcroppings, viewed from Central Park South (opposite) and from Central Park West in the mid-90s (above).

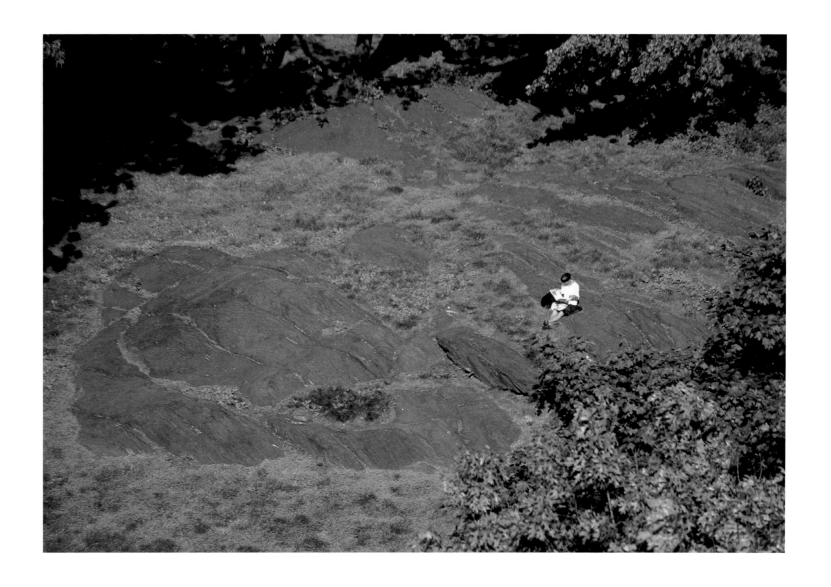

"From a high window looking down at the Harlem Meer, Central Park looks like the Loire Valley of France, with just a hint of Manhattan at its northern edge as your eye follows the water northward. The roof on the Dana Discovery Center forms the only hard geometry within this evocative scene of the winding lake and green crowds of trees."

ADRIAN BENEPE
Commissioner
New York City Department of Parks and Recreation

View of the Harlem Meer and the Charles A. Dana Discovery Center from the Schomburg Plaza at the corner of Fifth Avenue and 110th Street.

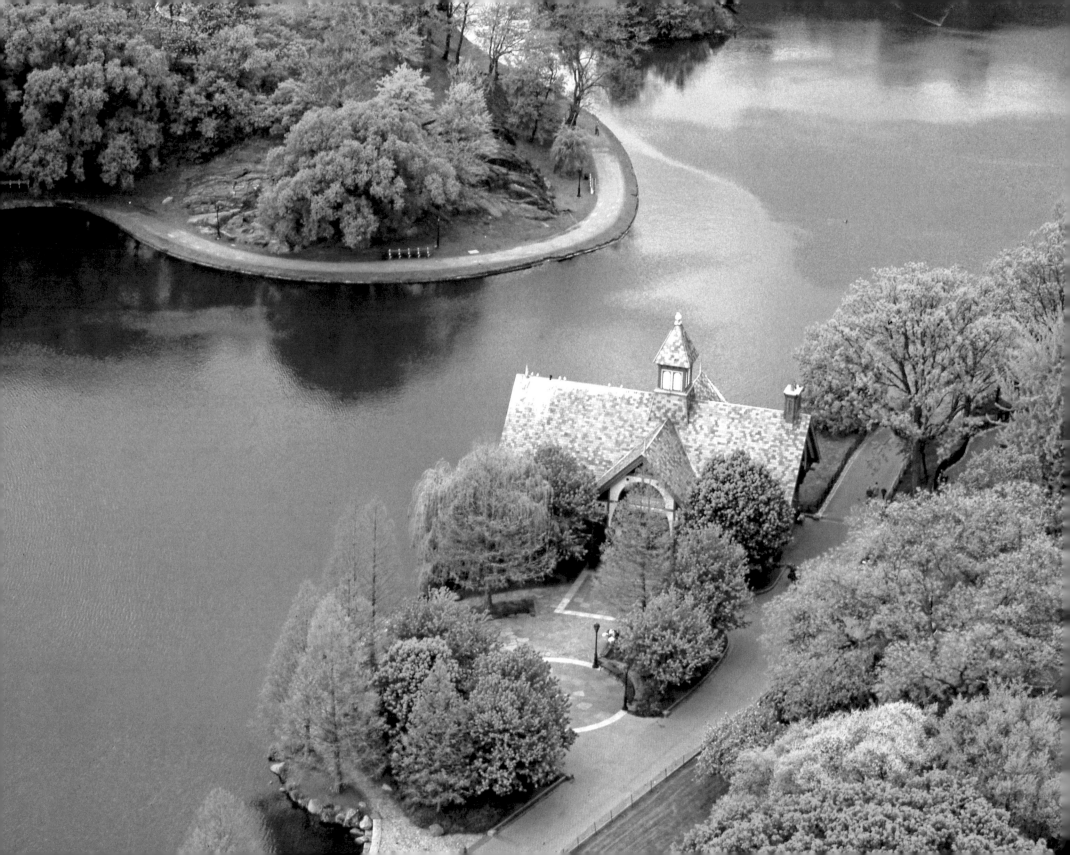

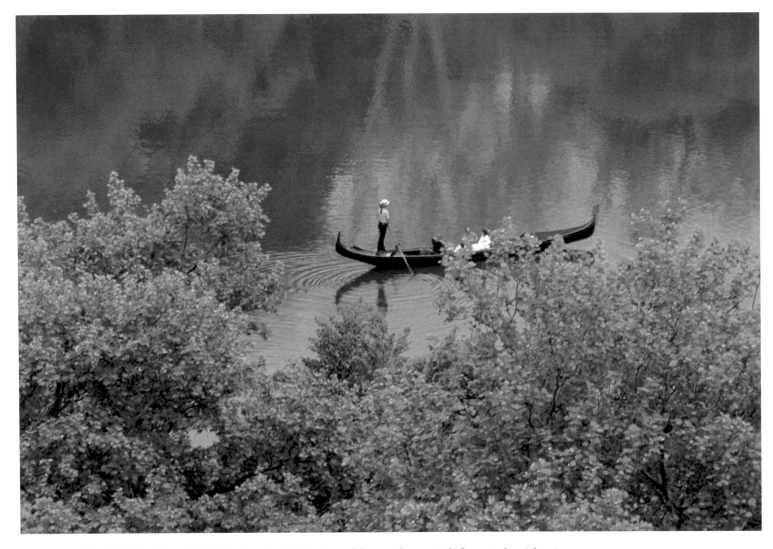

Two views of the Lake from Central Park West in the mid-70s: A gondola, seen from a 12th-floor window (above);
Hernshead Prominatory, seen from a 24th-floor window (opposite).

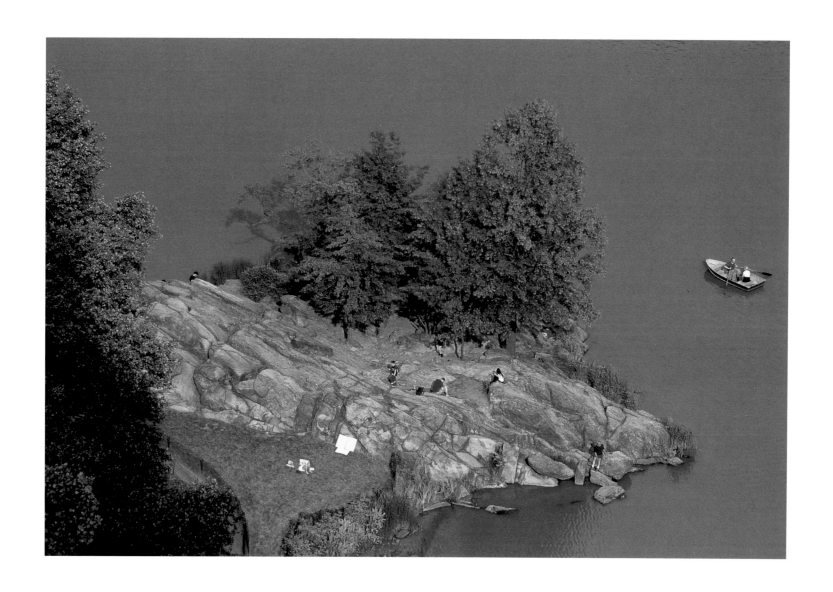

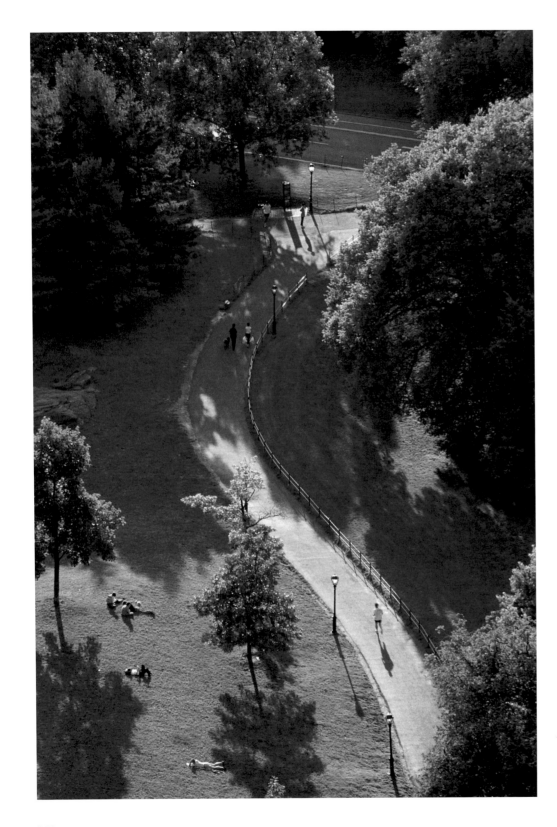

A pedestrian pathway, viewed from 85th Street near Madison Avenue.

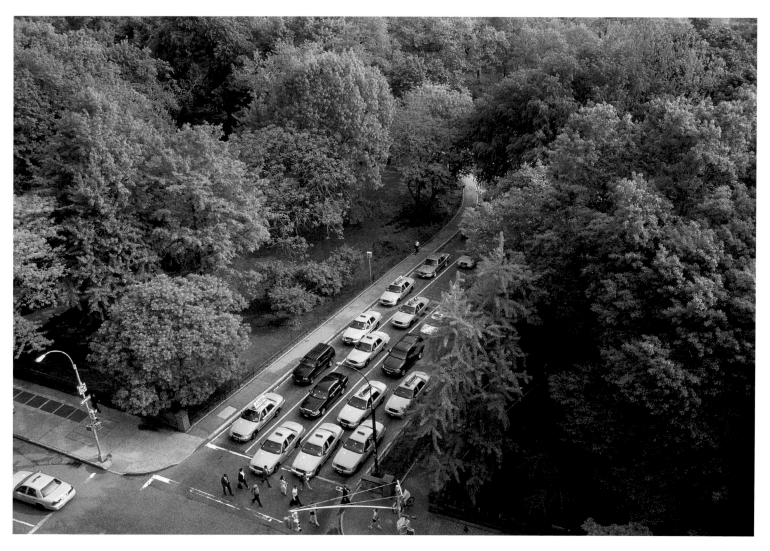

Park exit at 59th Street and Seventh Avenue, seen from Central Park South.

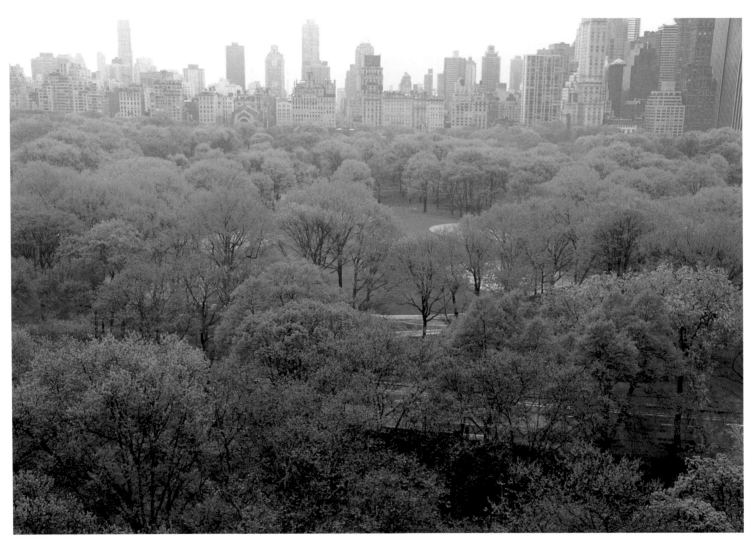

Spring trees around the Heckscher Ball Fields, viewed from Central Park West in the mid-60s.

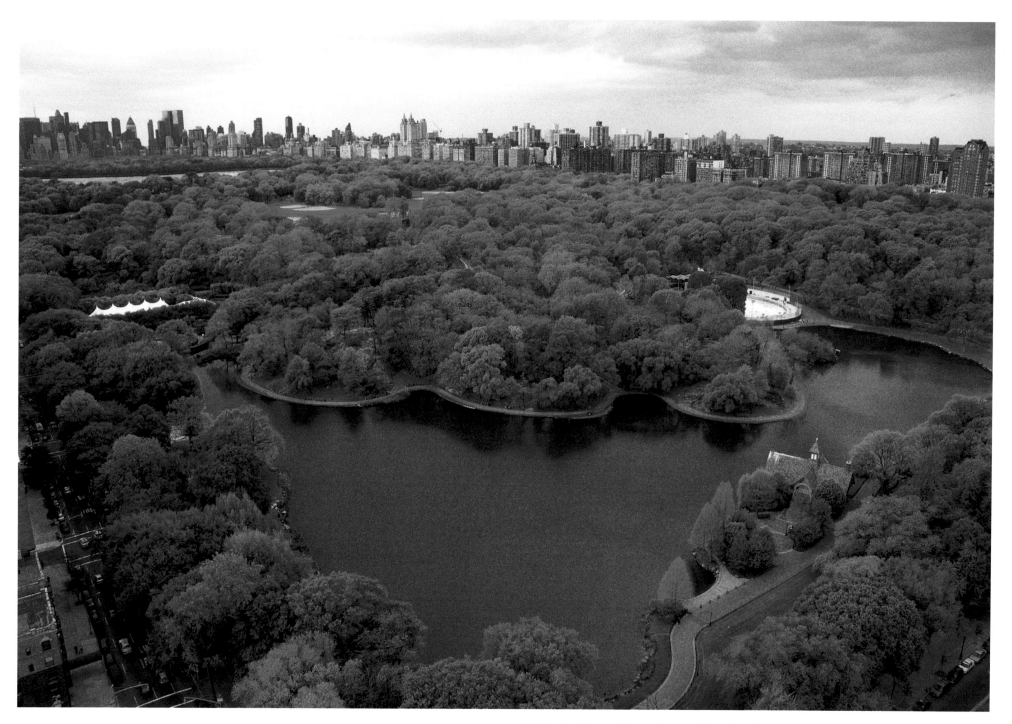

The Harlem Meer and beyond, viewed from the Schomburg Plaza at 110th Street and Fifth Avenue.

Two views of Turtle Pond, photographed from a tower window in Belvedere Castle (above and opposite).

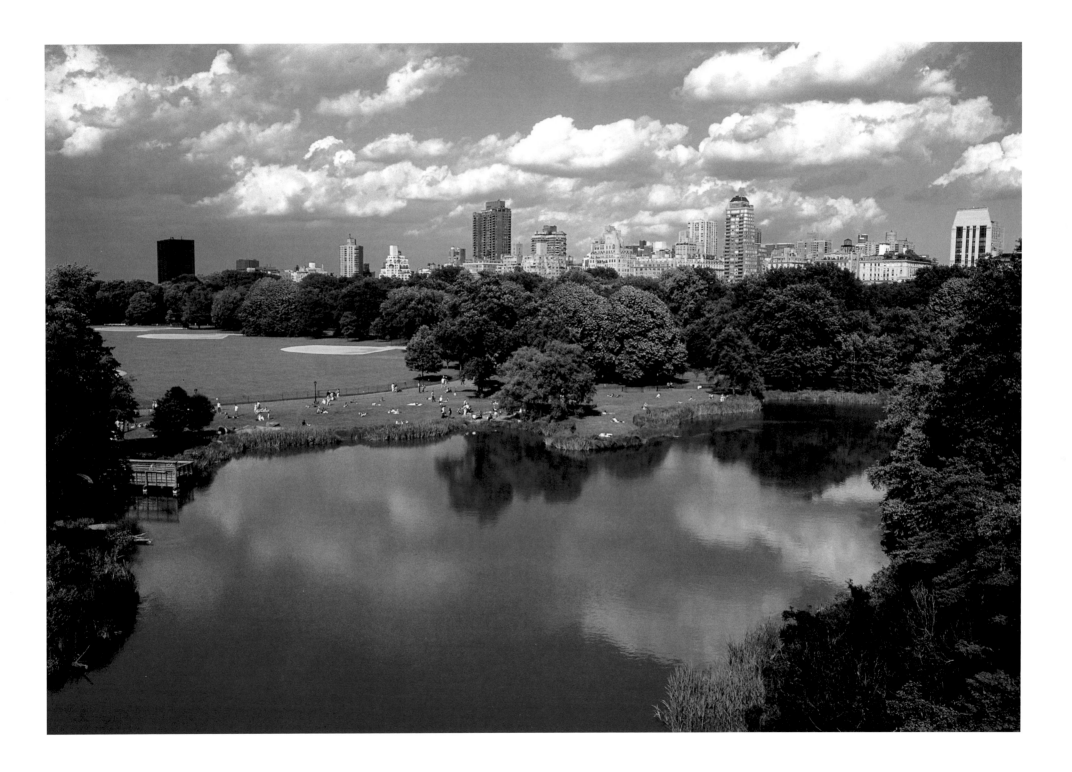

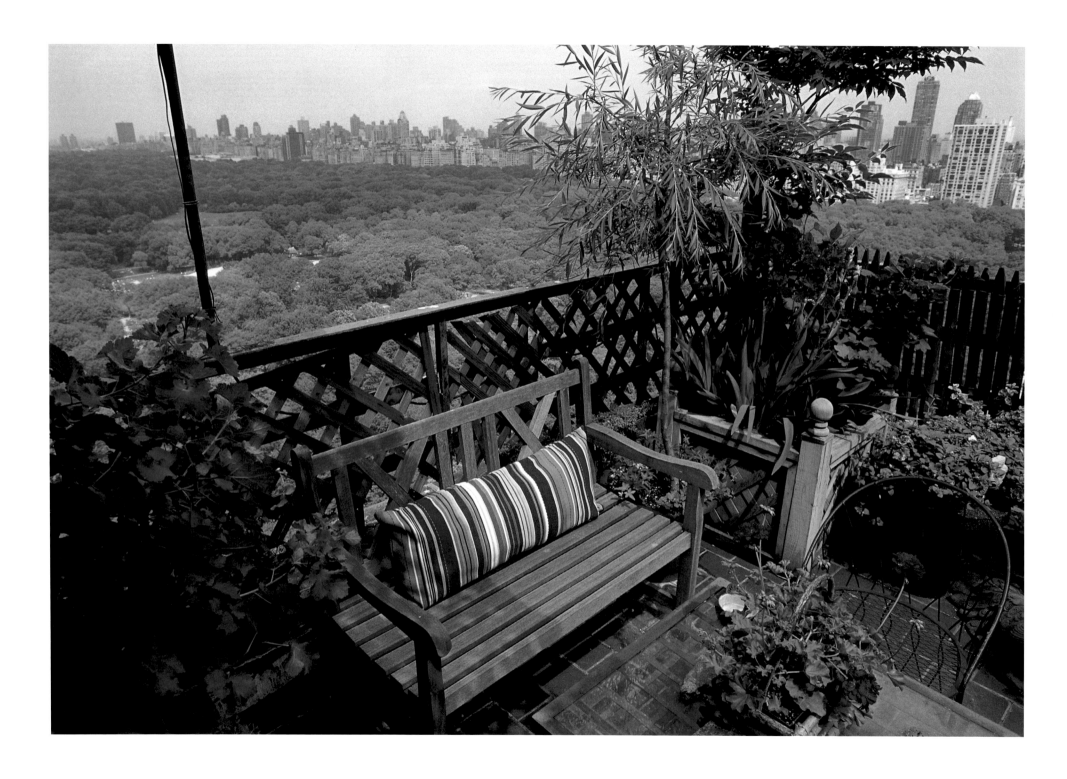

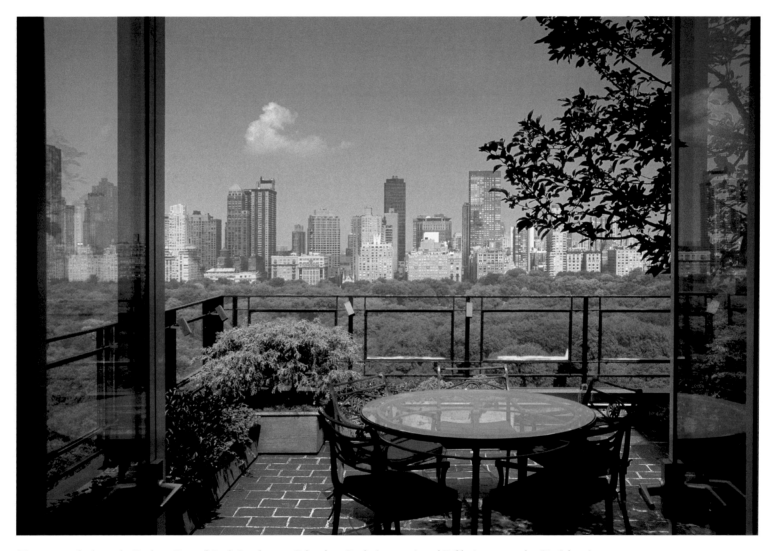

Terraces overlooking the Park at Central Park South near Columbus Circle (opposite) and Fifth Avenue in the 60s (above).

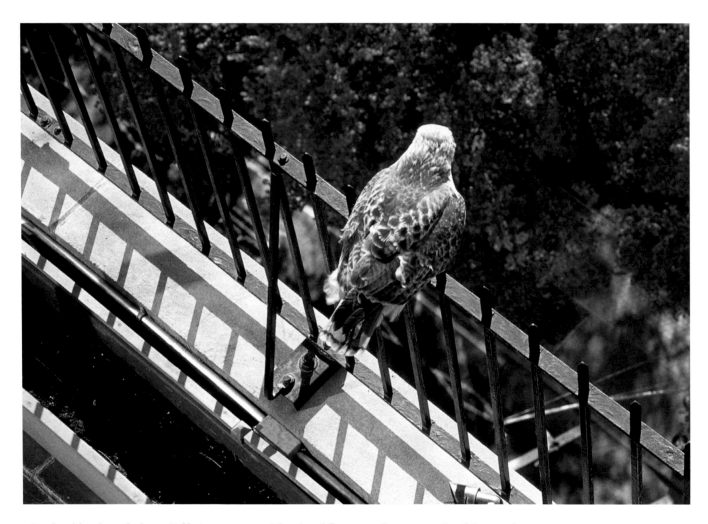

A red-tail hawk perched on a Fifth Avenue terrace (above) and flying over Conservatory Pond (opposite).

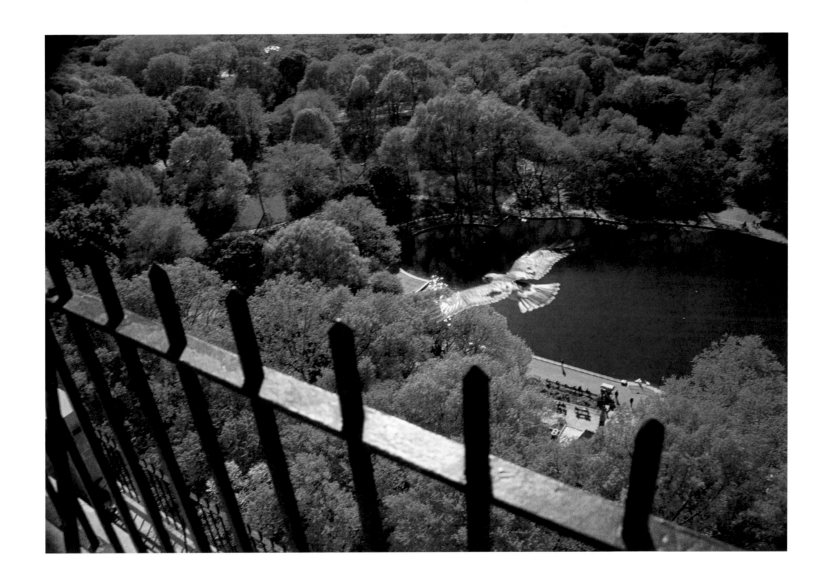

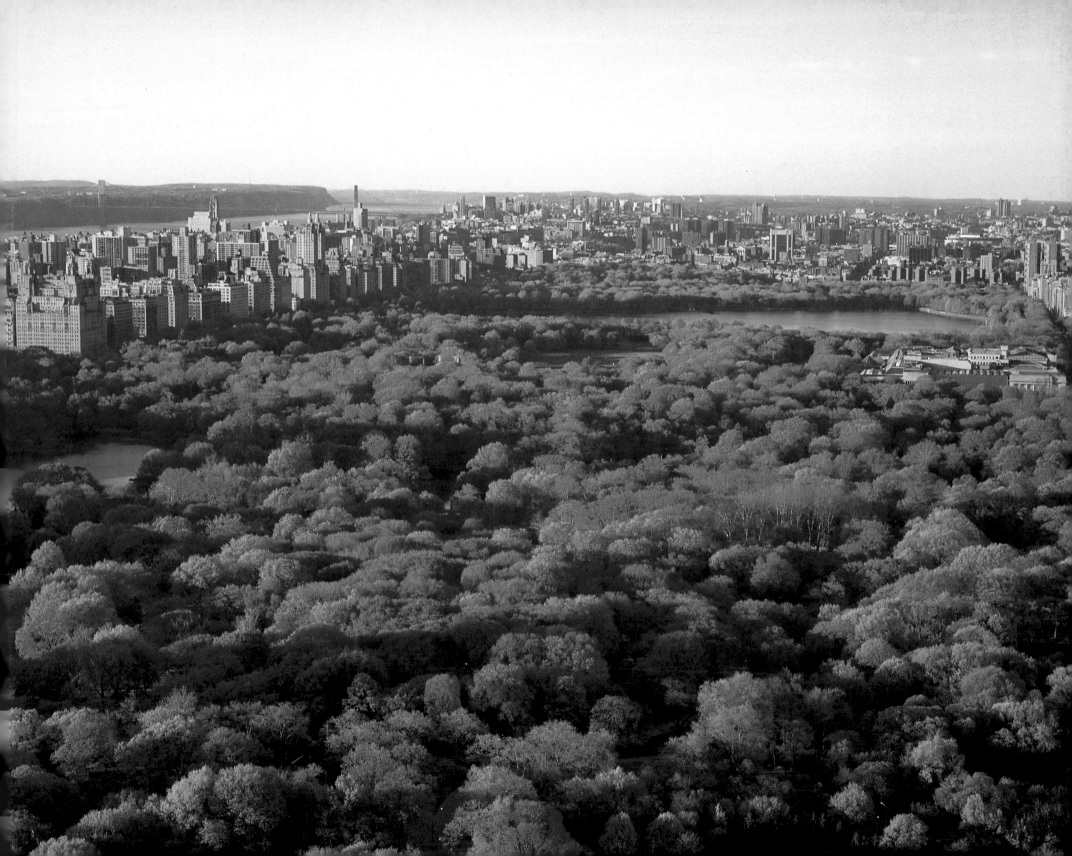

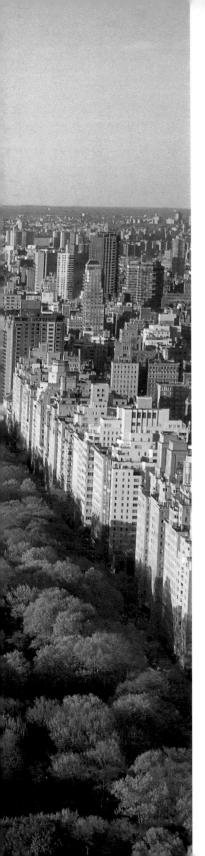

"All my life I have seen Central Park through my windows. It is the soul of the City. It is my country."

EVELYN H. LAUDER
Senior Corporate Vice President
The Estée Lauder Companies

Landscape, viewed from office windows at 9 West 57th Street.